Landscape painting sectors

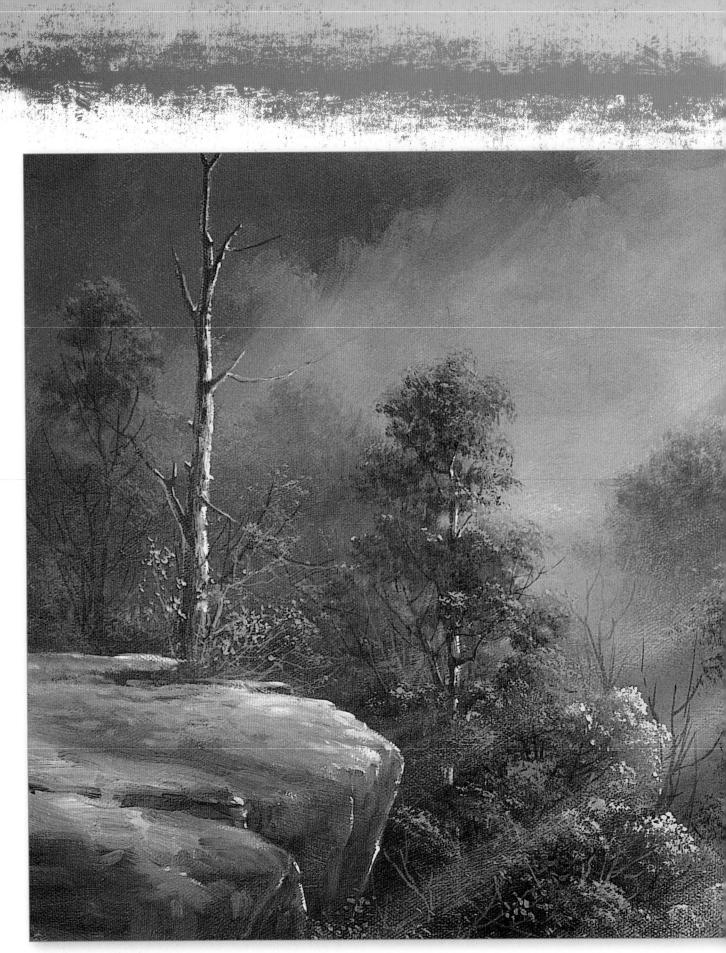

Autumn Wonders 12" × 16" (30cm × 41 cm)

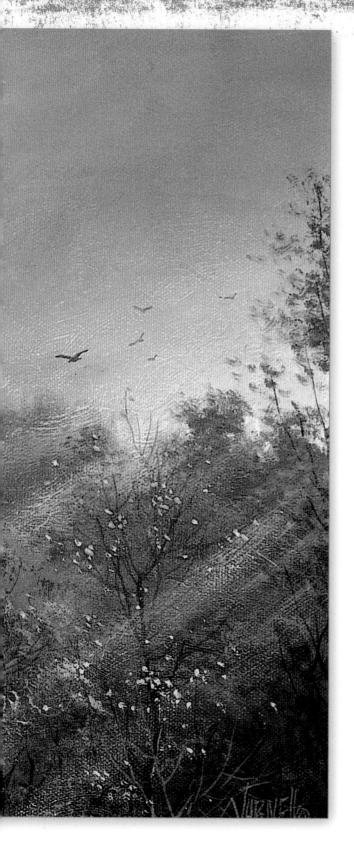

JERRY YARNELL'S Landscape Painting Secrets

JERRY YARNELL'S LANDSCAPE PAINTING SECRETS. Copyright © 2008 by Jerry Yarnell. Manufactured in China. All rights reserved. No part of this book may be reproduced in any form or by any electronic or mechanical means including information storage and retrieval systems without permission in writing from the publisher, except by a reviewer who may quote brief passages in a review. Published by North Light Books, an imprint of F+W Publications, Inc., 4700 East Galbraith Road, Cincinnati, Ohio, 45236. (800) 289-0963. First Edition.

Other fine North Light Books are available from your local bookstore, art supply store or direct from the publisher.

12 11 10 09 5 4 3 2

DISTRIBUTED IN CANADA BY FRASER DIRECT 100 Armstrong Avenue Georgetown, ON, Canada L7G 5S4 Tel: (905) 877-4411

DISTRIBUTED IN THE U.K. AND EUROPE BY DAVID & CHARLES Brunel House, Newton Abbot, Devon, TQ12 4PU, England Tel: (+44) 1626 323200, Fax: (+44) 1626 323319 E-mail: postmaster@davidandcharles.co.uk

DISTRIBUTED IN AUSTRALIA BY CAPRICORN LINK P.O. Box 704, S. Windsor NSW, 2756 Australia Tel: (02) 4577-3555

Library of Congress Cataloging in Publication Data Yarnell, Jerry. Jerry Yarnell's landscape painting secrets. -- 1st ed. p. cm. Includes index. ISBN-13: 978-1-58180-951-0 (pbk. : alk. paper) 1. Landscape painting--Technique. I. Title. II. Title: Landscape painting secrets. ND1342.Y36 2008 751.4'26--dc22 2007050411

EDITED BY JACQUELINE MUSSER DESIGNED BY JENNIFER HOFFMAN PRODUCTION COORDINATED BY GREG NOCK

About the Author

Jerry Yarnell was born in Tulsa, Oklahoma, in 1953. A recipient of two scholarships from the Philbrook Museum of Art in Tulsa, Jerry has always had a great passion for nature and has made it a major thematic focus in his paintings. He has been rewarded for his dedication with numerous awards, art shows and gallery exhibits across the country. His awards include the prestigious Easel Award from the Governor's Classic Western Art Show in Albuquerque, New Mexico, acceptance in the top one hundred artists represented in the national Art for the Parks competition, an exhibition of work in the Leigh Yawkey Woodson Birds in Art show and participation in a premier showing of work by Oil Painters of America at the Prince Gallery in Chicago, Illinois.

Jerry has another unique talent that makes him stand out from the ordinary: He has an intense desire to share his painting ability with others. For years he has held successful painting workshops and seminars for hundreds of people. Jerry's love for teaching also keeps him very busy holding workshops and giving private lessons in his new Yarnell Studio and School of Fine Art. Jerry is the author of nine books on painting instruction, and his unique style can be viewed on his popular PBS television series, *Jerry Yarnell School of Fine Art*, airing worldwide.

FOR MORE INFORMATION

about the Yarnell Studio and School of Fine Art and to order books, instructional videos and painting supplies, contact:

Yarnell Studio and School of Fine Art

P.O. Box 808, Skiatook, OK 74070 (877) 492-7635 (toll free), (918) 359-1805 (fax) gallery@yarnellart.com (e-mail) www.yarnellart.com

Metric Conversion Chart				
TO CONVERT	ТО	MULTIPLY BY		
Inches	Centimeters	2.54		
Centimeters	Inches	0.4		
Feet	Centimeters	30.5		
Centimeters	Feet	0.03		
Yards	Meters	0.9		
Meters	Yards	1.1		

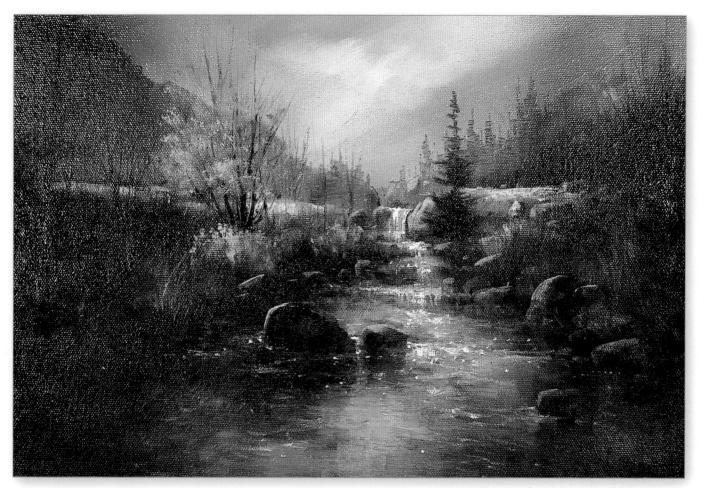

Peaceful Waters 12" × 16" (30cm × 41cm)

Dedication

It was not difficult to know to whom to dedicate this book. I give God all the praise and glory for my success. He blessed me with the gift of painting and the ability to share this gift with people around the world. He has blessed me with a new life after a very close brush with death. I am here today and able to share all of this with each of you because we have a kind, loving and gracious God. Thank you, God, for all you have done.

Also to my wonderful wife, Joan, who has now gone on to be with the Lord. I know she must have loved me or she would not have endured the hardships of an artist life and stuck with me all those years.

Lastly, to my two sons, Justin and Joshua: You both are a true joy in my life.

Acknowledgments

So many people deserve recognition. First, I want to thank the thousands of students and viewers of my television show for their faithful support over the years. Their numerous requests for instructional materials are really what initiated the process of producing these books. I want to acknowledge my wonderful staff, Diane, Scott and my mother and father for their hard work and dedication. In addition, I want to recognize the North Light Books staff for their belief in my abilities.

Table of Contents

Introduction	
Terms and Techniques	1
Getting Started	1
Understanding Complements	2

MINI DEMONSTRATIONS

Clumps of Grass	2
Weathered Wood and Wildflowers	2
Small Pebbles and Dirt	ŧ
Winding Dirt Road	ŧ
Stone Pathway	1
Stone Wall	4
Rocks	4
Eroded Banks	Ę
Ocean Waves	Ę
Running Water	:
Reflections in Water	6
Mud Puddles	5
Lightning	5
Rainbows	;
Leafy Trees	8
Dead Trees	ç
Snow–Covered Pine Trees	\$
Falling Snow	10

FULL PAINTINGS

Snow Country	
High-Country Waterfall	
Stormy Skies	

u and the state

Index

142

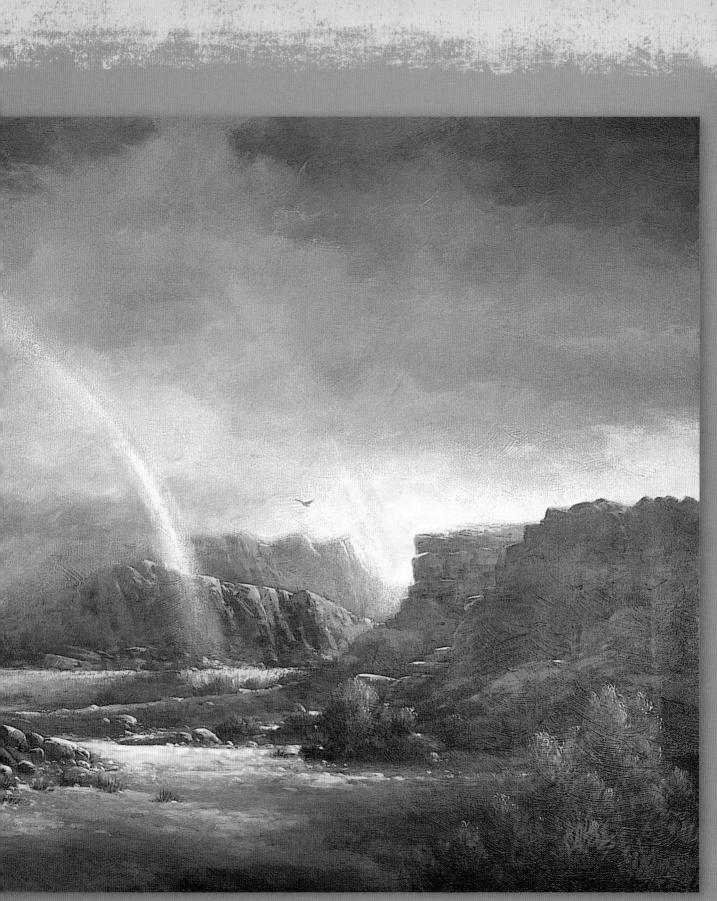

End of the Rainbow 24" × 30" (61cm × 72cm)

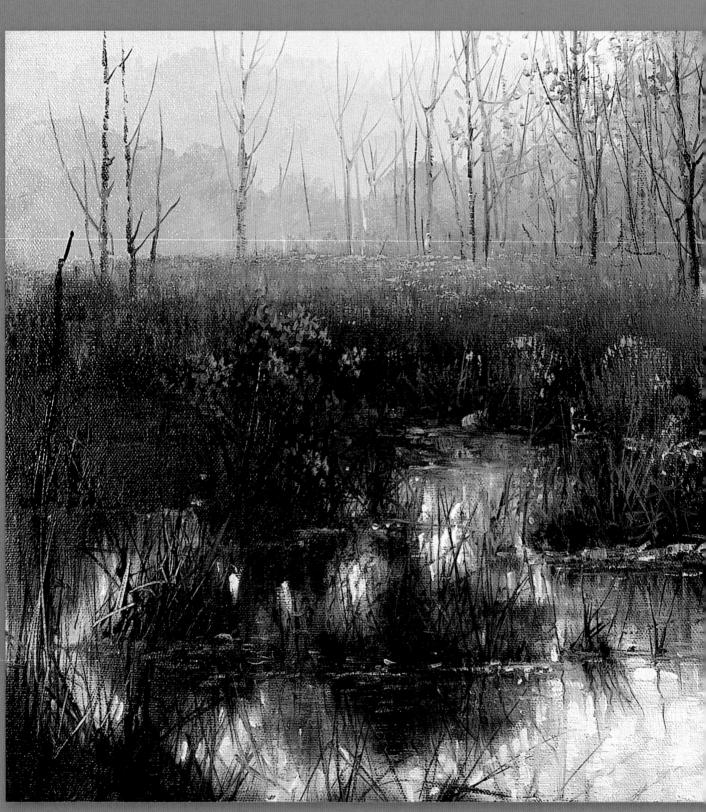

Net Hard

Peace Be Still 12" × 16" (30cm × 41cm)

Introduction

Hopefully by now you have had a chance to become familiar with the basic techniques of landscape painting through my previous books. Until now, we have only scratched the surface. Keep in mind that painting requires a lifetime of learning, practice, patience and experimenting. In this book of my landscape painting secrets, we will explore the many different areas of landscape painting that often create problems for most beginning and intermediate artists.

Over the years I have realized—for myself and my students-that sometimes the best way to learn new techniques, subjects and styles is to do a series of what we call thumbnail sketches or paintings. Thumbnail paintings are small practice segments of a painting you may be struggling with; thumbnails are done on scrap canvases. Maybe you're painting a landscape with a beautiful sunset, or a snowcapped mountain, or a waterfall with large boulders, and you're really struggling with the rocks in the waterfall or the water running over the rocks. Or maybe you just can't quite get the snow-capped mountain right. Well, I've discovered that by setting your painting aside, getting a scrap of canvas and working out your problems on that scrap instead of on the original canvas, you will have a tendency to learn faster. You will be less concerned about messing up on the thumbnail-study painting than you would working on the original. Artists generally are more relaxed and not as afraid to experiment with different techniques, color schemes and applications when they're working with smaller segments on a canvas board. Once you work out everything on the thumbnail, you'll have much more confidence to try the techniques on the original without as much fear of messing up your beautiful painting.

In this book we will primarily focus on thumbnail paintings to learn specific subjects, techniques, color schemes and more. I know you'll love this way of learning. It will be exciting, fun, and very informative. So grab your paints, brushes and some scraps of canvas or canvas boards and let's get started.

COLOR COMPLEMENTS

erms and Techniques

Complementary colors are always opposite each other on the color wheel. Complements are used to create color balance in your paintings. It takes practice to understand the use of complements, but a good rule of thumb is to remember that whatever predominant color you have in your painting, use its complement or a form of its complement to highlight, accent or gray that color.

For example, if your painting has a lot of green in it, use its complement—red—or a form of red, such as orange, red-orange or yellow-orange. If you have a lot of blue in your painting, use blue's complement—orange—or a form of orange, such as yellow-orange or red-orange. The complement to yellow is purple or a form of purple. Keep a color wheel handy until you have memorized the color complements.

CREAMY

In most of my books, you hear me use the word "creamy" in every study. For the acrylic technique, I teach the principle that the paint has to be very creamy for it to work correctly. In other words, when a mixture needs to be creamy, it should be like the consistency of soft butter.

DABBING

This technique is used to create leaves, ground cover, flowers, etc. Take a bristle brush and dab it on your table or palette to spread out the ends of the bristles like a fan. Then load the brush with an appropriate color and gently dab on that color to create the desired effect. (See above example.)

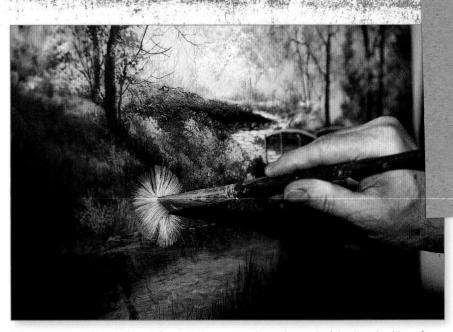

To prepare your bristle brush for dabbing, spread out the end of the bristles like a fan.

DOUBLE LOAD

Often it is necessary to put two colors on your brush to create a mottled effect, create special blends in a sky, or underpaint certain things like large, grassy areas, tree trunks, rock formations, etc. To double load, simply put one color on one corner of the brush and another color on the other corner of the brush. Then blend them together on the canvas itself.

DRYBRUSH

This term is often misunderstood. There are two aspects to drybrushing: loading and applying. To drybrush, take whatever mixture you are using and, after loading a very small amount on your brush, wipe some of it onto a paper towel or another surface. Once the brush is properly loaded, very lightly skim across the surface of the subject you are painting with very light pressure. Thus you have created a drybrush effect.

EYE FLOW

Eye flow is the movement of the viewer's eye through the arrangement of objects on your canvas or the use of negative space around or within an object. Your eye must move or flow smoothly throughout your painting or around an object. You don't want your eyes to bounce or jump from place to place. When you have a good understanding of the basic components of composition (design, negative space, "eye stoppers," overlap, etc.), your paintings will naturally have good eye flow.

FEATHERING

Feathering is a blending process used to soften the edges of certain objects. You take the color and carefully blend it in whichever direction you need until the color fades into the background and there are no visible edges where the colors are blended together. This is sometimes hard to do. It usually requires a dry-brush technique.

GESSO

The reason I put gesso on this list is because many of my students from around the world ask the question, "Why do you use gesso instead of white paint?" The answer is simple: Gesso is very opaque, and acrylic white paint is more transparent. For years, artists have been complaining about their acrylic paintings looking too "plastic." I used to complain, too. However, I discovered that because gesso is opaque (especially the thick gesso I use), mixing with acrylic takes away the plastic look. Gesso also softens colors, is much easier to blend and is great for creating texture. I have actually had judges at art shows think my acrylic paintings look like oil paintings because of my use of gesso, which adds more body to the paint. Be sure you use the thick, heavybodied gesso.

GLAZE (WASH)

A glaze or a wash is a very thin layer of paint applied on top of a dry area of the painting to create mist, fog, haze, sun rays or to soften an area that is too bright. This mixture is made up of a small amount of color diluted with water. It may be applied in layers to achieve the desired effect. Each layer must dry before you apply the next.

INKY

"Inky" is a term I use whenever I need to use the no. 4 sable script liner brush. This script brush will work properly only if the paint you are using is very thin. I like to compare this to an artist's ink called India ink, which is a black ink artists use to fill their sketch pens and calligraphy pens. It's very fluid. So when you create an inky mixture, be sure it has a similar consistency to that of India ink.

MOTTLED

Mottled means nothing more than applying several different colors at the same time in an unorganized fashion. This results in no distinct changes of color but rather various subtle changes of values and colors. Mottling works great for skies and all types of underpainting.

NEGATIVE SPACE

This is the area of space surrounding an object that defines its form. (See the example below.)

Here is an example of poor use of negative space. Notice the limbs do not overlap but are evenly spaced instead. There are a few pockets of interesting space.

Ander

Here is an example of good use of negative space. Notice the overlap of the limbs and the interesting pockets of space around each limb.

SCRUBBING

Scrubbing is simply a term that describes a technique for applying paint to your canvas. Scrubbing is typically used for underpainting and any other areas that don't need to be as refined or feathered. Scrubbing is more of a rough application of painting. Normally you will use bristle brushes to scrub because they can take the punishment this technique creates on a brush. Take the paint and use any and all parts of the brush to apply the paint in certain areas where a much rougher finish is acceptable. Use different pressures and be much more aggressive when scrubbing.

SCUMBLE

Scumbling is a bit like mottling. To scumble, use a series of unorganized, overlapping strokes in different directions to create effects such as clumps of foliage, clouds, hair, grass, etc. The direction of the stroke is not important for this technique.

SIX-FOOT VIEWING DISTANCE

I thought it would be a good idea to discuss the six-foot-viewing-distance rule. Over the years, I've noticed that when many students start painting, they spend most of their time painting while standing only a few inches from the canvas. The reality is that when you stand too close for too long, your eye will not focus properly and you will generally make more mistakes. You can see some things properly only from a distance, especially things like perspective and proportional issues. You may have heard the old saying "You are too close to the forest, to see the trees." This applies perfectly for artists. When you're painting, stand back about six feet every few minutes, not every hour. This allows your eyes to focus properly so you can make any necessary adjustments. The six-foot viewing distance is the main reason most fine art brushes have long handles-the long handles keep you at more of a distance. So try to get into the good habit of standing back frequently. I'm sure you will see a huge difference in the quality of your work.

UNDERPAINTING OR BLOCKING IN

These two terms mean the same thing. The first step in all paintings is to block in, or underpaint, the darker values of the entire painting. Then you begin applying the next values of color to create the form of each object.

VALUE

Value is the relative lightness or darkness of a color. To achieve depth or distance, use lighter values in the background and darker values as you come closer to the foreground. Raise the value of a color by adding white. To lower the value of a color, add black, brown or the color's complement.

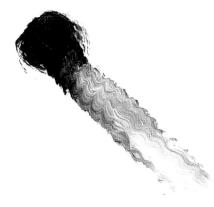

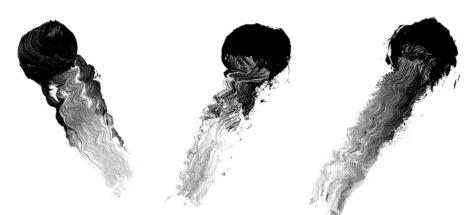

You can change the value of a color by adding white.

Getting Started

ACRYLIC PAINT

The most common criticism about acrylics is that they dry too fast. Acrylics do dry very quickly through evaporation. To solve this problem, I use a wet palette system, which is explained later in this chapter. I also use very specific dry-brush blending techniques to make blending very easy. If you follow the techniques I use in this book, with a little practice you can overcome any of the drying problems acrylics seem to pose.

Speaking as a professional artist, acrylics are ideally suited for exhibiting and shipping. An acrylic painting can actually be framed and ready to ship thirty minutes after it's finished. You can apply varnish over acrylic paint or leave it unvarnished because the paint is self-sealing. Acrylics are also very versatile because the paint can be applied thick or creamy, to resemble oil paint, or thinned with water for watercolor techniques. The best news of all is that acrylics are nontoxic and have very little odor, and few people have allergic reactions to them.

USING A LIMITED PALETTE

As you'll discover in this book, I work from a limited palette. Whether for my professional pieces or for instructional purposes, I've learned that a limited palette of the proper colors can be the most effective tool for painting. This palette works well for two main reasons: First, it teaches you to mix a wide range of shades and values of color, which every artist must be able to do; second, a limited palette eliminates the need to purchase dozens of different colors. As we know, paint is becoming very expensive. So, with a few basic colors and a little knowledge of color theory, you can paint anything you desire. This particular palette is versatile, so that with a basic understanding of the color wheel, the complementary color system and values, you can mix thousands of colors for every type of painting.

For example, you can mix Thalo Yellow-Green, Alizarin Crimson and a touch of white to create a beautiful basic flesh tone. These same three colors can be used in combination with other colors to create earth tones for landscape paintings. You can make black by mixing Ultramarine Blue with equal amounts of Dioxazine Purple and Burnt Sienna or Burnt Umber. The list goes on and on; you'll see the sky is truly the limit.

Most paint companies make three grades of paints: economy, student and professional. The professional grades are more expensive but much more effective to work with. The main idea is to buy what you can afford, and have fun. (Note: If you can't find a particular item, I carry a complete line of professional-grade and student-grade paints and brushes. Check page 5 for resource information.)

Materials List

PALETTE

White gesso Grumbacher, Liquitex or Winsor & Newton paints (color names may vary): Alizarin Crimson **Burnt Sienna** Burnt Umber Cadmium Orange Cadmium Red Light Cadmium Yellow Light **Dioxazine** Purple Hooker's Green Thalo (Phthalo) Yellow-Green (or Brilliant Yellow-Green) Titanium White Ultramarine Blue

BRUSHES

- 2-inch (51mm) hake
- no. 4 flat sable
- no. 4 round sable
- no. 4 script liner
- no. 4 bristle
- no. 6 bristle
- no. 10 bristle

MISCELLANEOUS ITEMS

no. 13 Conté pencil easel paper towels or rags palette knife no. 2 soft vine charcoal spray bottle Sta-Wet Palette stiff toothbrush 16" × 20" (41cm × 51cm) stretched canvas water can

BRUSHES

My selection of a limited number of specific brushes was chosen for the same reasons as the limited palette: versatility and economics.

2-Inch (51mm) Hake

The hake (pronounced ha-KAY) brush is a large brush used for blending. It's primarily used in wet-on-wet techniques for painting skies and large bodies of water. It's often used for glazing as well.

No. 4 Flat Sable

Sable brushes are used for more refined blending, detailing and highlighting techniques. They work great for final details and are a must for painting people and detailing birds or animals. They're more fragile and more expensive, so treat them with extra care.

No. 4 Round Sable

Like the no. 4 flat sable brush, this brush is used for detailing, highlighting, people, birds, animals, etc. The main difference is that the sharp point allows you to have more control over areas on which a flat brush will not work or is too wide. This is a great brush for finishing a painting.

No. 4 Script Liner

This brush is my favorite. It's used for the very fine details and narrow line work that can't be accomplished with any other brush. For example, use this brush for tree limbs, wire and weeds and especially for your signature. The main thing to remember is to use it with a much thinner mixture of paint. Roll the brush in an inklike mixture until a fine point is formed.

No. 10 Bristle

This brush is used for underpainting large areas—mountains, rocks, ground or grass—as well as dabbing on tree leaves and other foliage. This brush also works great for scumbling and scrubbing techniques. The stiff bristles are very durable, so you can be fairly rough on them.

No. 6 Bristle

A cousin to the no. 10 bristle brush, this brush is used for many of the same techniques and procedures. The no. 6 bristle brush is more versatile because you can use it for smaller areas, intermediate details, highlights and some details on larger objects. The nos. 6 and 10 bristle brushes are the brushes you will use the most.

No. 4 Bristle

The no. 4 bristle brush is a cousin to the no. 6 bristle. The reason I have added it to the collection is because as you do more advanced techniques, this brush because of its smaller size—allows you to have more control during the refinement process of your painting.

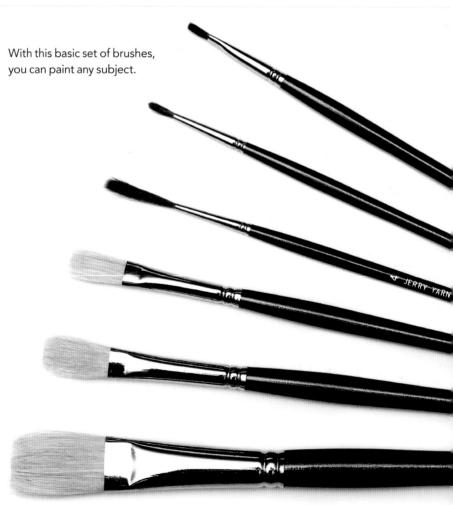

BRUSH-CLEANING TIPS

Remember that acrylics dry through evaporation. As soon as you finish painting, use good brush soap and warm water to thoroughly clean your brushes. Lay your brushes flat to dry. If you allow paint to dry in your brushes or your clothes, it's very difficult to get it out.

I use denatured alcohol to soften dried paint. Soaking the brush in the alcohol for about thirty minutes and then washing it with soap and water usually gets the dried paint out.

THE PALETTE

Acrylics dry through evaporation, so keeping the paints wet is critical. There are several palettes on the market designed to help keep your paints wet. The two I use extensively are Sta-Wet palettes made by Masterson. The first palette is a $12" \times 16"$ (30cm × 41cm) plastic palette-saver box with an airtight lid. This palette comes with a sponge you saturate with water and lay in the bottom of the box. Then you soak the special palette paper and lay it on the sponge. Place your paints around the edge and you're ready to go. Use your spray bottle occasionally to mist your paints, and they will stay wet all day long. When you're finished painting, attach the lid, and your paint will stay wet for days.

My favorite palette is the same $12" \times 16"$ (30cm \times 41cm) palette box, I don't use the sponge or palette paper. Instead I place a piece of double-strength glass in the bottom of the palette. I fold paper towels into long strips (into fourths), saturate them with water and lay them on the outer edge of the glass. I place my paints on the paper towel. They will stay wet for days. I occasionally mist them to keep the towels wet.

If you leave your paints in a sealed palette for several days without opening it, certain colors, such as green and Burnt Umber, will mildew. Just replace the color or add a few drops of chlorine bleach to the water in the palette to help prevent the mildew.

To clean the glass palette, allow it to sit for about thirty seconds in water, or spray the glass with your spray bottle. Scrape off the old paint with a single-edge razor blade. Either palette is great. I prefer the glass palette because I don't have to change the palette paper. CORNER FLAT SIDE METAL FERRULE Brush diagram

Here are two different ways to set up your palette.

ng Up Your Palette

PALETTE 1

The Sta-Wet 12" \times 16" (30cm \times 41cm) plastic palettesaver box comes with a large sponge, special palette paper and an airtight lid.

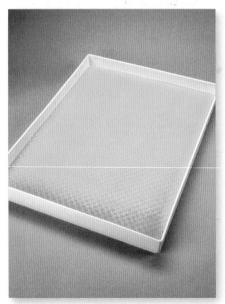

Saturate the sponge with water. Lay the sponge inside the palette box.

Next, soak the special palette paper and lay it on the sponge. Place your paints around the edge. Don't forget to mist your paints to keep them wet.

When closing the palette-saver box, make sure the lid is on securely. When the palette is properly sealed, your paints will stay wet for days.

PALETTE 2

Instead of using the sponge or palette paper, another way to set up your palette box is to use a piece of double-strength glass in the bottom of the palette. Fold paper towels in long strips and saturate them with water to hold your paint.

Lay the saturated paper towels on the outer edges of the glass.

Place your paints on the paper towel. I place my paints on the palette in this order: Titanium White or Gesso, Cadmium Yellow Light, Cadmium Orange, Cadmium Red Light, Hooker's Green, Burnt Sienna, Burnt Umber, Ultramarine Blue, Dioxazine Purple, Brilliant Yellow Green, Alizarin Crimson

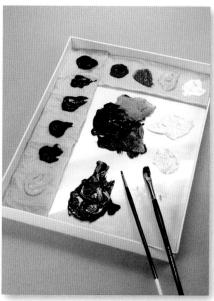

Use the center of the palette for mixing paints. Occasionally mist the paper towels to keep them wet.

To clean the palette, allow it to sit for thirty seconds in water, or spray the glass with a spray bottle. Scrape off the old paint with a single-edge razor blade.

CANVAS

There are many types of canvas available. Canvas boards are fine for practicing your strokes, as are canvas paper pads for doing studies or for testing paints and brush techniques. The best surface to work on is a primed, prestretched cotton canvas with a medium texture, which can be found at most art stores. As you become more advanced in your skills, you may want to learn to stretch your own canvas. I do this as often as I can, but for now a 16" × 20" (41cm × 51cm) prestretched cotton canvas is all you need for the paintings in this book.

EASEL

I prefer to work on a sturdy standing easel. There are many easels on the market, but my favorite is the Stanrite 500 aluminum easel. It's lightweight, sturdy and easy to fold up to take on location or to workshops.

LIGHTING

Of course, the best light is natural north light, but most of us don't have this light available in our work areas. The next best light is 4' or 8' (1.2m or 2.4m) fluorescent lights hung directly over your easel. Place one cool bulb and one warm bulb in the fixture; this best simulates natural light. $16" \times 20"$ (41cm \times 51cm) stretched canvas

SPRAY BOTTLE

I use a spray bottle with a fine mist to lightly mist my paints and brushes throughout the painting process. The best ones are plant misters or spray bottles from a beauty supply store. It's important to keep one handy.

SOFT VINE CHARCOAL

I prefer to use soft vine charcoal for most of my sketching; it's very easy to work with and shows up well. It's also easy to remove or change by wiping it off with a damp paper towel.

CONTÉ PENCIL

時時 在4.1.57%的

Usually when we do sketching for these paintings, we use a no. 2 soft vine charcoal because it is easy to work with, easy to remove and shows up on most surfaces. However, there are times when the area you are working on may be very dark, and the charcoal may not show up. So sometimes I like to use a Conté pencil. It's a soft, white, French pastel pencil, and it must be a no. 13. This shows up well on dark areas and is easily removed with a damp paper towel.

PALETTE KNIFE

finest quality

artists' charcoal Improved, Smoother Drawing Sticks

I do not do a lot of palette-knife painting; I mostly use a knife for mixing. A trowel-shaped knife is more comfortable and easier to use than a flat knife.

Spray bottle
Soft vine charcoal

- 3. Palette knife
- 4. Conté pencil

CHARCOAL

A WORD ABOUT MAHLSTICKS AND THE STEDI REST SYSTEM

All of us at one time or another will have days when we are not as steady as we would like to be. Perhaps you're working on something that requires a lot of close-up detail work, or your painting is still wet and you can't steady your hand on the canvas while painting. The solution to these problems is called a mahlstick. I use it, along with a little gadget called a Stedi-Rest.

These photos show the use of a mahlstick both with and without the Stedi-Rest. Either way, a mahlstick is a *must* for most painters. Really, a mahlstick is nothing more than a dowel rod about 36" (91cm) long that can be purchased from any hardware store. The Stedi-Rest must be purchased from an art store. I carry both items at my studio for my students (see page 5 for more information). The mahlsticks I stock are handmade from special woods and finishes.

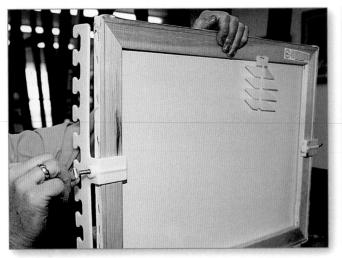

Attaching the Stedi-Rest is a simple matter of screwing the bracket onto the side of your stretcher strip.

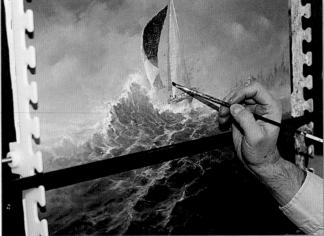

Placing a Stedi-Rest on each side of the painting will allow you to work in several different horizontal positions.

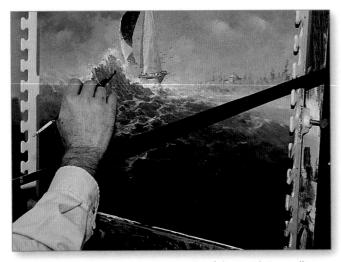

Using your mahlstick on only one side of the Stedi-Rest allows you to work from several different angles.

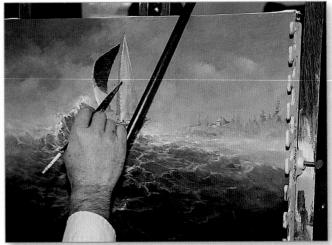

The mahlstick can be used without the Stedi-Rest by placing it at the top of the canvas to give you more vertical positions.

Understanding Complements

By the time you begin studying these books, you may have had some experience with the color wheel. However, I've noticed that many students still don't have a clear understanding of complements, the value system and graying colors. I would like to spend a little time discussing these issues as they pertain to landscapes. Note: There's much more in-depth study of the color wheel in my technique book.

Most landscape painters use a color wheel of grayed complements. As you probably know, a standard color wheel is made up of three primary colors (red, yellow, blue), three secondary

colors (green, violet, orange) and six (intermediate) tertiary colors (redorange, yellow-orange, yellow-green, blue-green, blue-violet, red-violet). In their pure forms, these colors are too bright to do a traditional landscape. Most artists create their own version of a grayed color wheel. For my color wheel, I use Hooker's Green, Cadmium Red Light and Cadmium Yellow Light as my primary colors, and mix the secondary and intermediate colors from these. Often we need to gray the colors to achieve the desired effect. We gray a color by adding its complement or a form of its complement.

· 1.18%的 (1%)

For example, suppose you want to use Hooker's Green, but it looks too intense for a particular area of your painting. Simply add some of its complement, which is found on the opposite side of the color wheel. You could add touches of Cadmium Red Light, Cadmium Orange, red-violet, redorange, yellow-orange, etc. These are all forms of complements to Hooker's Green. Use this process for all the colors. To gray purple, add yellows or forms of yellow. To gray orange, add blue or forms of blue, and so on around the wheel.

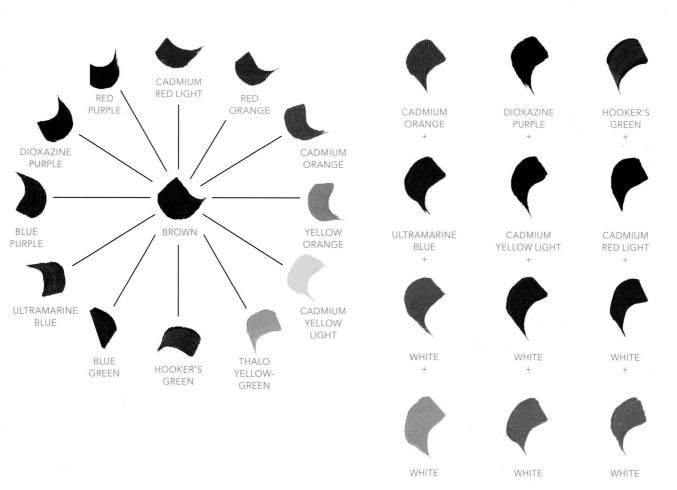

THUMBNAIL STUDY

Clumps of Grass

In many landscape paintings, there are times when you need to have clumps of grass and brush to help with the composition and to create fillers to finish the middle and foreground areas of the painting. The problem, however, arises when you paint the clumps in perfect rows and evenly space them apart. This can cause your eye to bounce around the painting instead of gracefully flowing through it, and the unnaturally placed clumps may compete with the main center of interest.

Underpaint Ground (Dirt)

First, create a mixture of one part Burnt Sienna + one part Burnt Umber + about one-fourth part white; then add a little touch of Cadmium Yellow Light. Take your no. 10 bristle and scrub this color mixture on the area where the grass clumps will be placed. Use short, choppy, vertical strokes to create a slight suggestion of rough dirt.

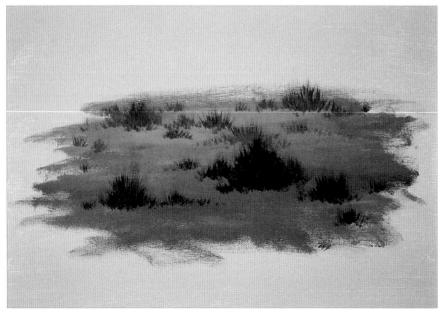

) Underpaint Clumps

Create a mixture of one part Hooker's Green + one part Burnt Sienna + one-fourth part Dioxazine Purple. Make the mixture very creamy and then load a small amount on the end of a no. 6 bristle. Locate where you want to place a clump. Then, starting at the base of the clump, use a short, vertical stroke and pull upward to create a soft, grasslike effect. This is something you should probably practice on a scrap of canvas until you get the hang of it. Remember to check the placement of each clump so you create interesting pockets of negative space with good eye flow.

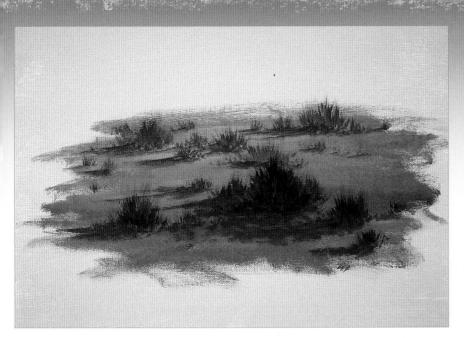

Paint Shadows

For the shadows, mix one part Burnt Sienna + about one-fourth part Dioxazine Purple + a touch of white to create a softer value. Take your no. 4 bristle and scrub in the cast shadows on the left side of each clump, following the contour of the ground. You may need to thin the mixture with water a little bit so it will smudge a little easier on the canvas. Let dry.

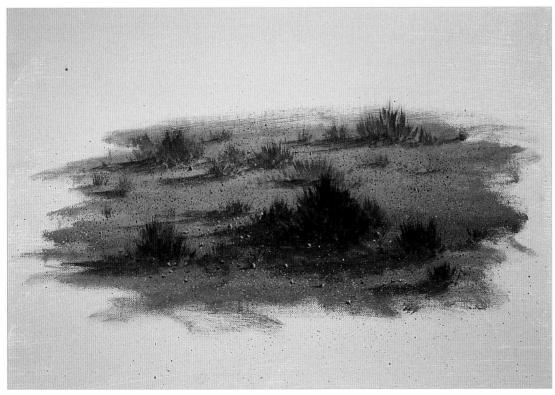

Add Pebbles and Small Rocks

This is a really fun step. You will need a fairly stiff toothbrush. Create two or three very fluid, inky mixtures of your favorite light colors (for instance, white with a touch of Cadmium Yellow Light, Orange, or Red Light). Load the toothbrush fairly heavily with the mixtures and then rub your forefinger across the bristles, spattering these lighter colors all over the ground. If you happen to overspatter on the clumps, take a damp paper towel and wipe off the splatter. Do the same thing with some darker colors. This will give you a very "pebbled" look.

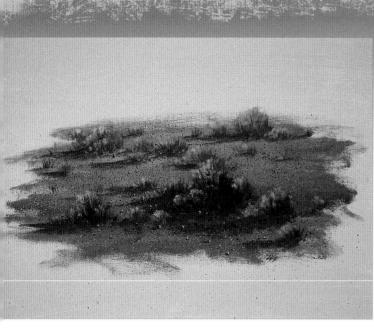

Tighlight Clumps of Grass

Create a very creamy mixture of Thalo Yellow-Green + a slight touch of Cadmium Orange. Use your no. 6 bristle to dab this color on the topside of each of the clumps of grass. This creates a nice variety of three-dimensional clumps. Be very careful not to overhighlight; use a very light touch as you dab the highlights onto the clumps.

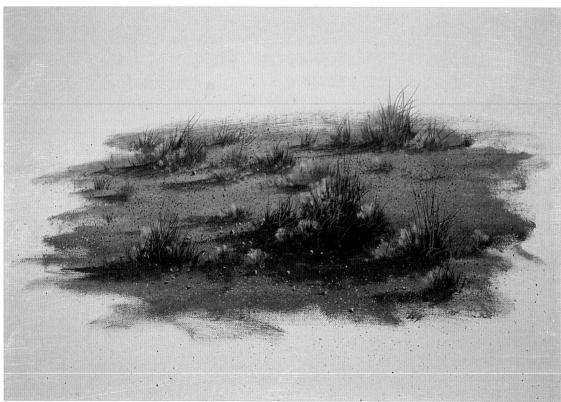

🔟 Add Tall Weeds

Make a mixture of one part Hooker's Green + one-fourth part Dioxazine Purple. Make this mixture very inky by adding a lot of water. Take your no. 4 script liner and roll it around in the mixture until it forms a nice, sharp point. Add the taller weeds throughout the clumps of grass. Be sure you create taller weeds and shorter weeds, in addition to overlapping them to make the clumps look more interesting. You also can do this with light colors if you desire.

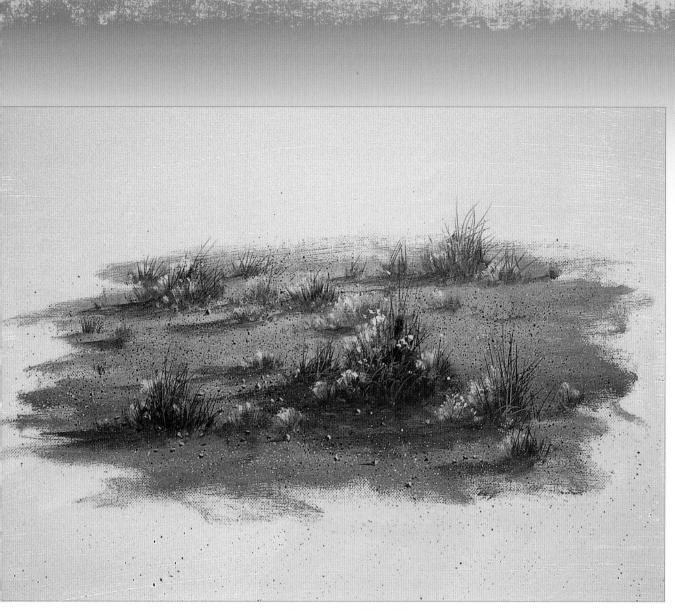

Add Flowers and Final Details

There isn't much to this step. It's mostly a matter of adding a few very bright, simple flowers. Do this by taking your favorite colors and adding a little touch of gesso to make each color opaque. Make the mixture very creamy. Take your no. 4 bristle and dab little touches of these colors throughout the clumps of grass. You can add more weeds if you need to and even a few more pebbles or small rocks. Just be careful to add all these final details in moderation.

THUMBNAIL STUDY

Weathered Wood and Wildflowers

This is a great study; you're going to have a lot of fun with this one. It may be a little challenging, but it's not as difficult as it looks. The technique for creating weathered wood is primarily a dry-brush technique, and it can be used to re-create many surfaces. This study is primarily focused on an old picket-fence post, but this technique works well for old buildings, tree bark, wooden porches or old wooden tabletops and wooden floors. Get ready to have a great time!

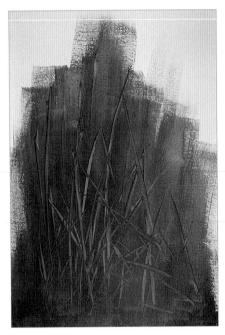

Underpaint Background

First, create a mixture of Hooker's Green + a little bit of Burnt Sienna + a little bit of Dioxazine Purple. Use water to thin it down to the consistency of a very thick, creamy soup or chowder. With your hake brush, paint the background using long, sweeping vertical strokes. You want the background to be a little sloppy. While this is still wet, clean the hake and form a chisel edge on its tip by running the hairs of the brush between two of your fingers. (This will also remove any excess water.) Turn the brush vertically to the canvas and lift off some of the background color to suggest distant, taller weeds.

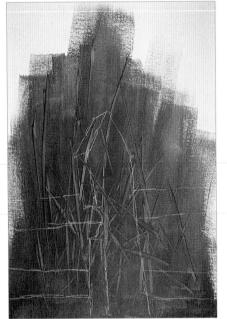

) Create Basic Sketch

Use a white Conté pencil to roughly sketch the fence. In most rough sketches of general landscapes, you don't need to be too accurate. However, in this case you will want to be very accurate, so make sure you're happy with your sketch before you go on to the next step.

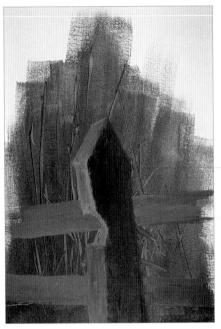

Underpaint Fence

Create a mixture of one part Ultramarine Blue + one-fourth part Burnt Sienna + a small amount of white. This should be a medium dark gray. If you want this gray to be a little on the warm side, add a little more Burnt Sienna, if necessary. Take a little bit of this base gray and lighten the value by adding enough white to create a value about three shades lighter than the original.

Take your no. 4 or no. 6 bristle and block in the front of the post with the dark-value gray. Block in the rest of the fence with the lighter-value gray.

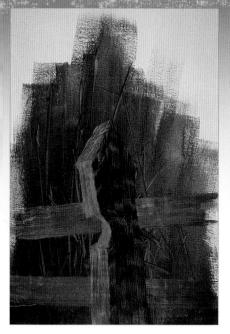

Paint Wood Grain This is a fascinating step. You need a fairly new no. 4 bristle that has a nice straight chisel edge. Lighten the lighter-value gray by adding more white. Thin it to a very creamy mixture and evenly load a very small amount across the tip of the brush. Wipe off a little of it with a paper towel so it's a little drier.

Carefully and lightly drag the brush across the surface of the fence, creating the suggestion of wood grain. This takes practice, so you may have to redo this a few times. You will probably have to experiment with different degrees of moisture to create different effects.

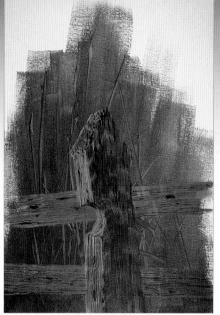

5 Paint Knotholes and Cracks For this step, create a very dark mixture of one part Ultramarine Blue + one-fourth part Burnt Sienna + a little dab of Dioxazine Purple. Thin this down to a creamy, almost inklike consistency. Take your no. 4 script liner and paint in a few dark knotholes. You can now make the mixture very inky and roll your brush in the mixture until it forms a point. With this, paint in some of the cracks and miscellaneous wood-grain lines.

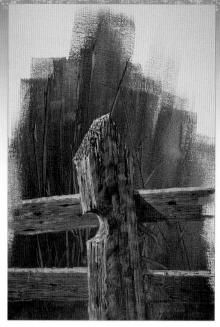

Highlight Fence You'll want to do some minor highlighting to give the fence a little more life and a three-dimensional form. Create a mixture of white with a touch of Cadmium Orange. Use your no. 4 round sable to paint in the top of the back rails to give them dimension. Take your brush and drybrush a few scattered highlights throughout the post and rails. Be very careful not to overhighlight, as you want to only accent the rails and post.

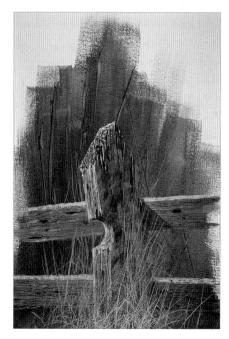

Paint the Weeds

Mix about three different light values of yellows and greens (these color recipes are up to you). Be sure to add a little white to the mixtures to make them opaque. Thin them down to a very inky consistency. Take your no. 4 script liner and paint a large variety of weeds. Be sure some of them are very tall and overlap each other. Also, be sure some are behind the fence post and rails.

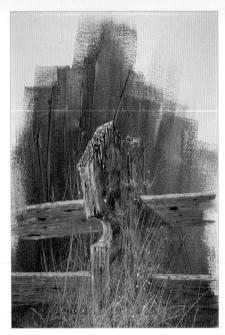

> Paint Flowers: Phase 1

These flowers are very simple to paint. First, take three or four of your favorite bright colors. For example, you can take Cadmium Red Light, which is a good complement to the green weeds, and then maybe Cadmium Orange, Cadmium Yellow Light, or even white. Make these mixtures very creamy. Load the very tip of your no. 4 flat bristle with each of these colors. Dab on suggestions of flowers throughout the area around the fence, creating a nice balance of color and composition. Use different parts of the brush and pressures to create a variety of shapes.

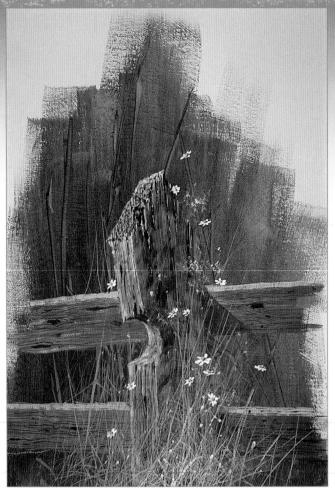

🔪 Paint Flowers: Phase 2

This step simply adds the white daises. I normally create a dull, grayish white. By mixing white with a very slight touch of Ultramarine Blue and Burnt Sienna, you will actually be making a tint. Make the tint creamy and use your no. 4 round sable to paint in the petals, forming the basic shape of the flower. Put a dab of pure Cadmium Orange right in the center of the flower.

Take pure Titanium White and highlight the right side of the flower petals. This gives the flower a bit more form. Take a little touch of Burnt Umber and paint a small shadow on the right side of the orange center to give it a little more of a three-dimensional look.

The important thing about these flowers is that you place them close to the center post and try to give them slightly different angles and groupings to create good eye flow.

Note: You may, at this point, want to add more highlights to the post and rails and, perhaps, add a few more cracks. Be sure to paint the cast shadow from the post onto the rails. Notice that the shadow is at an angle.

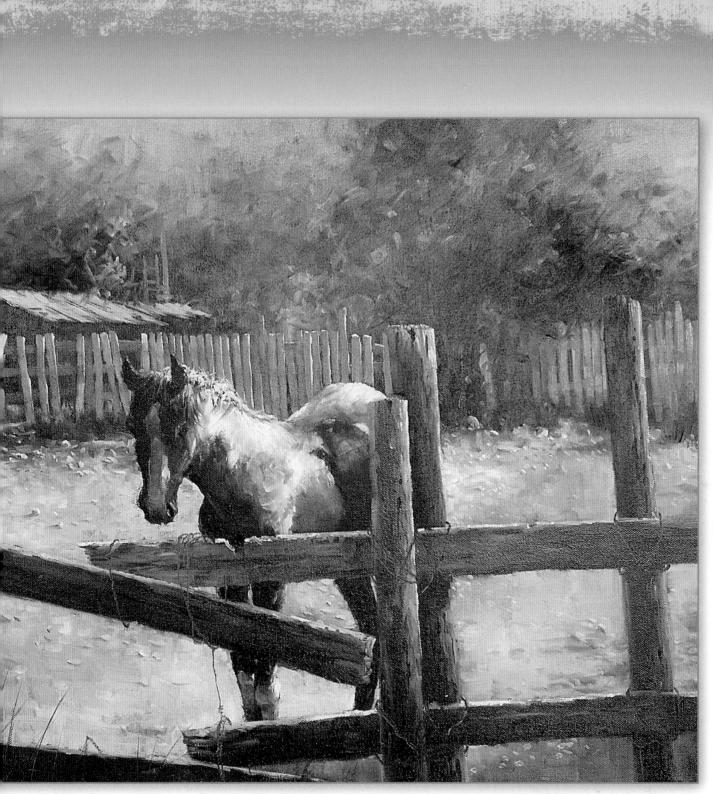

Indian Pony 18" × 24" (46cm × 61cm)

Apply the Lesson

As I mentioned in the study, the technique for creating weathered wood has many applications. In this finished painting, titled *Indian Pony*, you can see where I used this technique. The weathered wood added much more interest to the old rounded fence posts and also to the flat, horizontal braces.

THUMBNAIL STUDY

Small Pebbles and Dirt

This is one of the more fascinating studies you will see in this book. Not only is it interesting and artistic, but you can make it literally look photographic if you choose. I have noticed that many artists struggle with creating sand, dirt, pebbles, etc. However, with the technique I'm going to show you here, you will see it is really not that difficult to create very realistic pebbles and dirt that can add great interest to a landscape painting. Grab your toothbrush and let's make pebbles!

Underpaint Ground (Dirt)

Start with a medium-dark underpainting. Create a mixture of one part Burnt Sienna + one-half part Burnt Umber + one-eighth part Dioxazine Purple. Block in the underpainting with a no. 10 bristle using broad, horizontal strokes. If the canvas doesn't cover well, let it dry and repeat the step.

) Highlight Dirt

Create a lighter area through the middle of the background. Add a little white and a touch of Cadmium Orange to the original underpainting color until the value is about two shades lighter than the original. With the no. 10 bristle, scrub this color across the middle area, gradually fading it out from the middle upward and from the middle downward.

Underpaint Larger Pebbles and Shadows

To add pebbles that are too large for the toothbrush, create a mixture of one part Burnt Sienna + one part Dioxazine Purple. Then dab on a variety of these larger pebbles with a no. 4 round sable. At the same time, smudge a shadow on the left side of each of the larger pebbles.

Spatter Dirt: Phase 1

For this step, you need a fairly stiff toothbrush. Mix a couple of light values: white + a touch of Cadmium Yellow Light, and white + a touch of Cadmium Orange. Mix a couple of dark colors: one part Dioxazine Purple + one part Burnt Sienna, or even a pile of plain Burnt Umber. Make each mixture very soupy, then load the toothbrush.

Rub your forefinger across the brush. This creates little round pebbles. You can adjust the size of your pebbles by how fluid or dry your color mixture is. The size also will change depending on how heavily you load the toothbrush and by how far away from the canvas you hold the brush.

It's a good idea to practice this on a scrap of canvas until you get the hang of it. Use this process for each shadow and highlight color.

🖵 Highlight Pebbles

For the highlight, mix white + a touch of Cadmium Orange. Use a no. 4 round sable to paint the highlight on the top-right side of each pebble. Depending on the color scheme of your painting, you can change the highlight to almost anything you want.

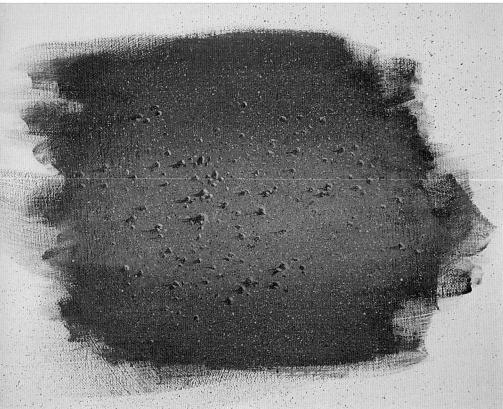

Spatter Dirt: Phase 2

This step is designed to add multiple colors of pebbles to the dirt. In an effort to create color harmony, depending upon the overall color scheme of the painting, you can use Ultramarine Blue, Hooker's Green, Cadmium Red, Dioxazine Purple or any color you want. Just be sure to add a little bit of gesso to each color to make it more opaque. Repeat the process used in step 3 and you will see the dirt really come alive.

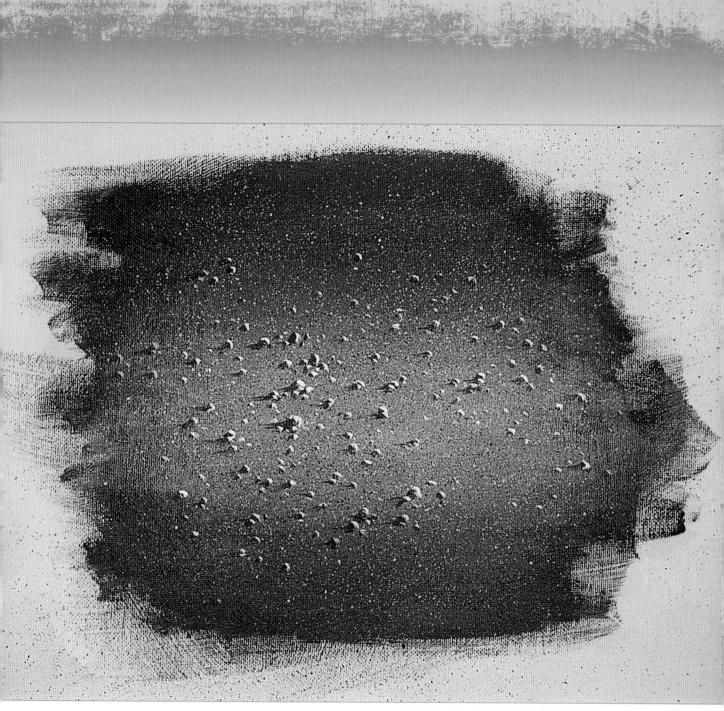

γ Add Final Highlights on Pebbles

Remember that acrylics have a tendency to dry darker, so the original highlight color you used in step 5 may have dried less bright than you intended. If this is the case, rehighlight each of the larger pebbles with the same highlight color you used before.

THUMBNAIL STUDY

Winding Dirt Road

Dirt roads are fascinating and are a great compositional asset. Like a winding pathway, stream or river, a road is a great subject to use to encourage one's eye to flow into a painting. In this study, I will show you how to blend the dirt, create banks and make the road appear flat as it winds its way into the background.

H-Pastalina and

Create Basic Sketch

As usual, grab your soft vine charcoal and draw a rough sketch of the main shape of the road and the contour of the land.

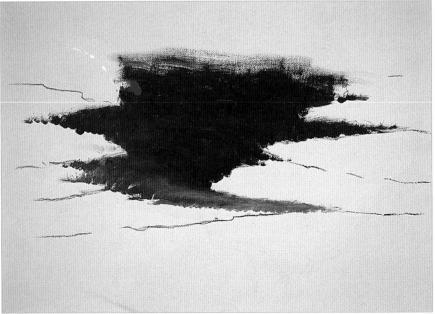

) Underpaint Road

You need a fairly dark background on which to layer the lighter colors. Take your no. 10 or no. 6 bristle and use Burnt Umber and Burnt Sienna mixed together on the canvas. Use short, choppy, horizontal strokes. Make sure the canvas is completely covered. Paint the edges out past the original sketch just a little to compensate for the grass that will overlap the banks. Use comma strokes for the banks to make them darker.

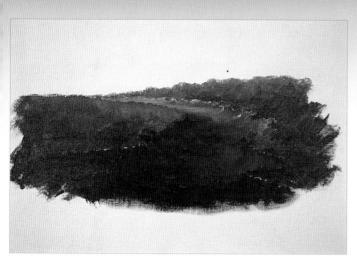

🔍 Underpaint Grass

If you've been following my other books, you have probably done this grass technique several times. If so, this step should be fairly easy. First, create a mixture of one part Hooker's Green + one-fourth part Burnt Sienna + a touch of Dioxazine Purple. Take your no. 10 bristle and begin scrubbing this color on the grassy areas. Apply the paint very thickly. After you scrub on the color, while it is still wet, take your brush and push upward against the canvas. This creates a bit of a grasslike texture. The important thing is to put on a thick coat of paint.

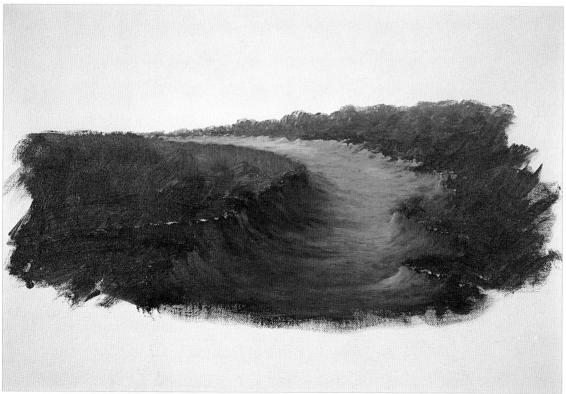

Highlight Road

Mix a soft, middle-tone tan from one part Burnt Sienna + one-fourth part Burnt Umber + one-fourth part Cadmium Yellow Light + one-fourth part white. Thin the mixture with water to a very creamy consistency. With a no. 4 flat bristle, begin applying the highlight, starting at the back of the road, using short, choppy, horizontal strokes. Make the road darker as you come forward by adding some of the original dark mixture to the highlight color. As a result, your road should end up with three values: light, middle and dark. It is OK if you see brushstrokes, as this creates a more dirtlike effect.

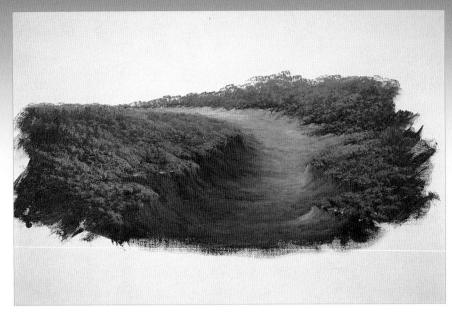

Highlight Grass

To highlight the grass, create a greenish mustard color by mixing one part Thalo Yellow-Green + one-fourth part Cadmium Orange. Load a small amount on the very tip of a no. 6 bristle and dab on to the underpainting to create various contours in the ground. As always, be sure to leave a variety of interesting pockets of negative space. You can add brighter highlights later, so don't worry if the grass is not quite as bright as you would like it to be.

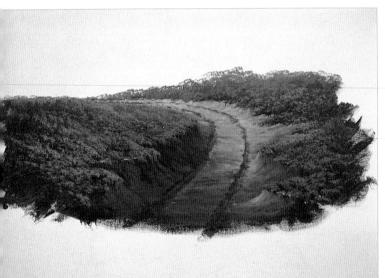

🗋 Paint Ruts

Ruts add great character to a road. If you're unsure of the location of the ruts, it might be a good idea to take your soft vine charcoal and sketch in your preferred location for them. Then, with a mixture of Burnt Sienna + a touch of Dioxazine Purple, take your no. 4 flat sable and paint in the ruts, beginning at the back of the road. Remember, objects are always a little lighter in the background, so you will have to add a touch of white to the mixture for the background ruts. Use short, horizontal strokes to paint the ruts. This will create an irregular edge that suggests the ruts have eroded. Notice that the ruts become a little wider as they come forward.

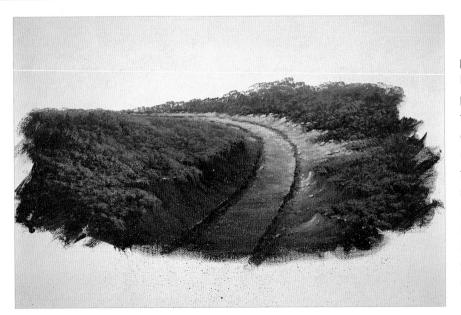

🍸 Detail Road

This step is mainly for adding pebbles, small rocks, and highlights. If you refer to the study on painting pebbles and rocks (page 30), you can follow those instructions exactly to create the effect you need for this road. Grab your toothbrush and go to that section of the book, and have fun spattering the road. Create a highlight mixture of white + a touch of Cadmium Orange. Use a no. 4 flat sable to highlight the edges of the banks and to paint a few larger pebbles along the edge of the road.

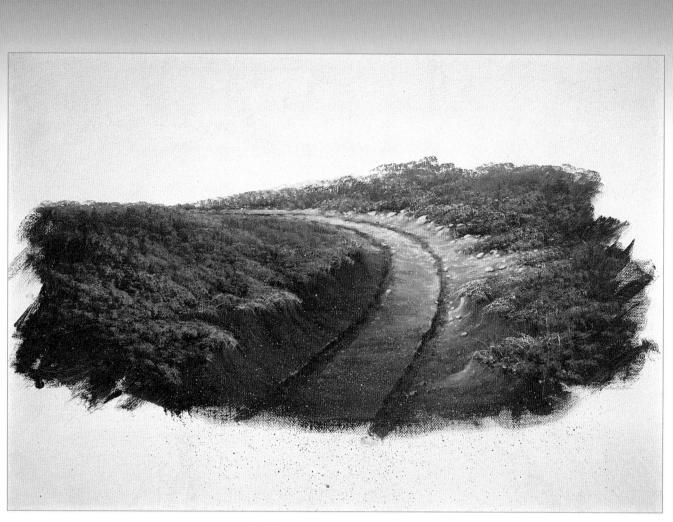

📿 Add Final Details and Highlights

Mix your favorite highlight color, such as Thalo Yellow-Green + a touch of Cadmium Yellow Light, or Cadmium Yellow Light + a touch of Cadmium Orange. You can even use pure Cadmium Yellow Light, or pure Thalo Yellow-Green. Use a no. 6 bristle to dab on these highlights throughout the grassy areas. Concentrate mostly toward the edges of the banks.

Use a couple of pure complementary colors and dab on a few wildflowers with a no. 6 or no. 4 bristle. You may want to put a few highlights along the edges of the ruts to give them a little more of a three-dimensional look.

THUMBNAIL STUDY

Stone Pathwary

Sometimes a winding pathway entering into a painting can be the key to creating a great composition, especially if the pathway is made out of stone. However, most student artists have trouble making the stones appear as if they are lying flat, which obviously is the secret to making the pathway as a whole appear flat. To draw and paint a flat stone, you must create an ellipse—a round object that takes on an oval shape depending upon the angle at which you view it. My main goal here is to help you see how to make the pathway appear to be lying flat.

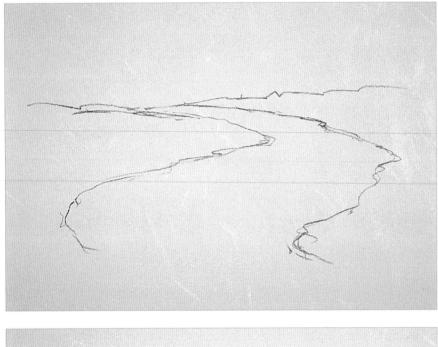

Create Basic Sketch

With soft vine charcoal draw a very rough sketch of the shape of the pathway and the ground formation around the pathway. Keep it simple—it will change, anyway, as you begin to paint.

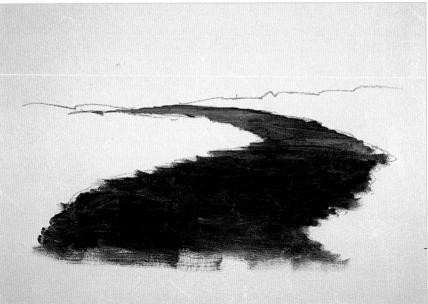

🅤 Underpaint Pathway

Create a dark mixture of one part Burnt Sienna + one part Burnt Umber + about one-eighth part Dioxazine Purple. Take either a no. 6 or no. 10 bristle and paint on the color using short, choppy, horizontal strokes. Don't be afraid to add additional touches of Burnt Sienna, Burnt Umber or even a little white here and there to create minor color and value changes. Be sure the canvas is well covered.

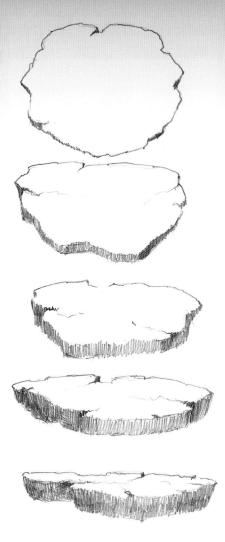

Understanding Ellipses

Before we go on, make sure you have a complete understanding of what an ellipse is and how to use one in a painting. The illustration at left shows the evolution of an ellipse. The top is a full view of a stone standing on its edge. As you begin to lay the stone down (at more of an angle), it appears to become flatter. This flattened circle is an ellipse.

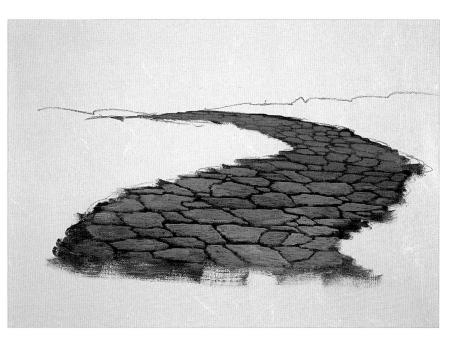

🔰 Underpaint Stones

Now that you have an idea of what an ellipse is, you may want to use a white Conté pencil to sketch in the shape of all your rocks before you start painting. Otherwise, you can shape them with your brush as you begin to paint.

The stone color is made up of the original underpainting color + little bit of white and a little bit of Cadmium Orange. This creates a value that is about two to three values lighter than the underpainting. I normally use a no. 4 flat bristle to paint the stones, but you can use a no. 4 flat sable if you wish.

Thin the mixture to a very creamy consistency and then simply fill in the shape of each rock. Keep in mind that the stones are smaller in the background and become larger as you move toward the front of the pathway. Be sure to leave a thin space between each stone.

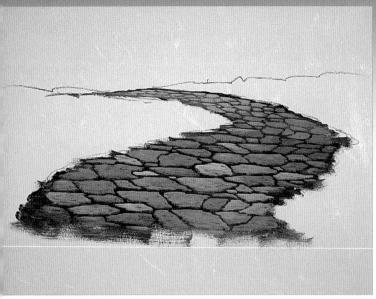

Highlight Stones

To create better color harmony, use a variety of colors when highlighting the stones. The best way to accomplish this is to start with a base highlight color made of white + a slight touch of Cadmium Orange. Then you can add any color you want to the base. A touch of Hooker's Green, Ultramarine Blue, Cadmium Red Light, Cadmium Yellow Light, etc. can be used here. Thin each of these colors to a very creamy consistency. Load a small amount on your no. 4 flat sable and begin highlighting each stone with whichever highlight color you choose. There is no particular order, but don't overhighlight.

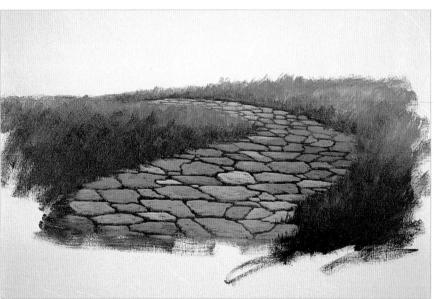

🛫 Underpaint Grass

To settle the stones into the landscape, scrub in some grass on both sides of the pathway. Mix Thalo Yellow-Green with a little Hooker's Green and use your no. 10 bristle. Scrub the light areas in the background by pushing upward, creating a grassy texture. As you come forward, begin adding more Hooker's Green and touches of Burnt Sienna and Dioxazine Purple until the foreground grass is very dark.

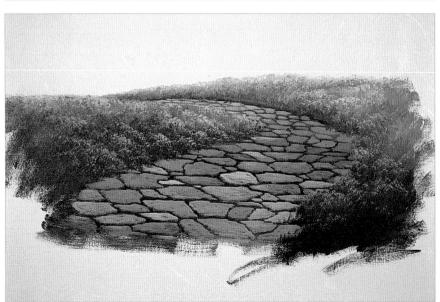

🚬 Highlight Grass

Create a very creamy mixture of one part Thalo Yellow-Green + a small touch of Hooker's Green and, if you like, a bit of Cadmium Yellow Light and/or a bit of Cadmium Orange. Load the very tip of a no. 6 or no. 10 bristle and dab the highlight color on the grass, leaving very interesting pockets of negative space. This helps create contour to the ground formations. Don't be afraid to experiment with various colors and values.

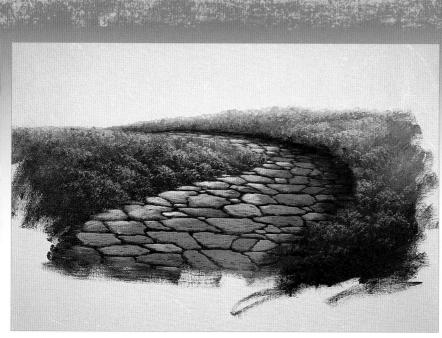

Add Shadows and Highlights Add a little white to the original highlight colors used in step 4. Then, with a no. 4 bristle or no. 4 flat sable, highlight the stones mostly on the left side of the pathway and towards the back.

Mix up a shadow color of Burnt Sienna + a touch of Dioxazine Purple, making it very creamy. Take your no. 4 bristle and scrub in the cast shadow on the right side of the road making sure you gradually fade the shadow out towards the center of the road.

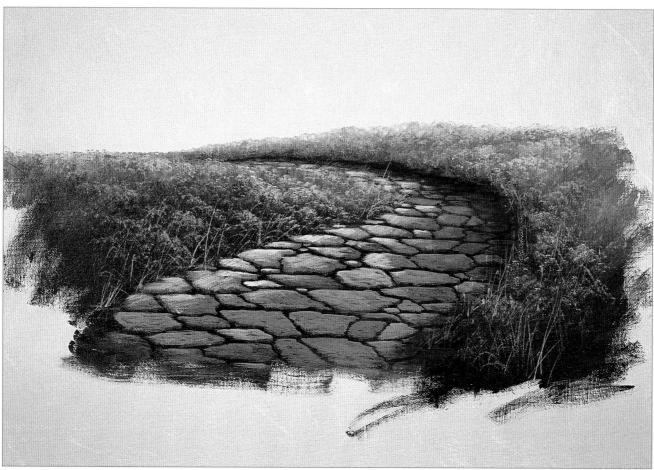

📿 Add Final Details

At this stage, have fun highlighting the grasses by using your favorite flower color and dabbing some suggested flower shapes throughout the grassy areas. Then, use your no. 4 script liner to create some inky mixtures of light- and dark-value greens and paint in some taller weeds.

You will really enjoy this study. Unlike the stone-pathway study (page 38), where we concentrated on the stones laying flat to create an elliptical effect, the stones here are standing on their sides facing you, so you can see their full, distinct shape. The technique demonstrated here can be used for any type of stone. Stone walls, stone fences, stone pillars, etc. can add tremendous interest and artistic value to many types of landscapes.

Landscape Secret

Star was

Print Appine S

Throughout this study, be sure you apply the paint thin enough to allow the underpainting to show through. This is the secret to creating texture and adding that third dimension to any object.

Create Basic Sketch

With your soft vine charcoal, draw a quick, rough outline of the shape of the wall.

🅤 Underpaint Wall

For the underpainting, create a mixture of one part Burnt Umber + one part Burnt Sienna + about oneeighth part Dioxazine Purple. Load this color onto a no. 6 or no. 10 bristle and paint in the wall area. Be sure the canvas is covered well. Let dry.

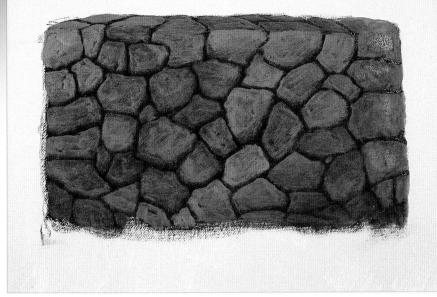

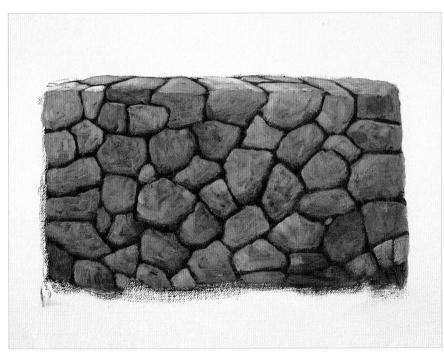

Highlight Stones

Notice how many colors you see here: pinks, tans, grays, golds, etc. To add color and keep the stonelike effect, add a little more white to the color you used in step 3. This is your base highlight color. Then add small amounts of whatever color you want to the base and scrub the color on a few rocks. Create another color and apply it to a few other rocks. Continue to create colors and add them to the rocks until you have a nice, interesting collection of multicolored stones. Be sure not to make them too opaque. You can use your no. 4 bristle or no. 4 sable for this step.

Underpaint Stones

If you're not very skilled with using a paintbrush to draw, or if you don't feel secure using your brush without a guideline, use a white Conté pencil to draw in each stone until you're happy with the arrangement. Then paint in the stones.

Create a warm, middle-tone gray mixture by adding a bit of Ultramarine Blue and white to the original background color. You should be able to see the gray color. Add enough white to create a value about three shades lighter than the background. Thin the mixture to a very creamy consistency and load a very small amount on a no. 4 bristle. It doesn't take much paint to underpaint the stones; your stones will look more realistic if you apply the paint thinner so some of the background shows through. If you put the paint on too heavily and the stones are too opaque, you will lose the nice, mottled, stone-like effect created by the layers.

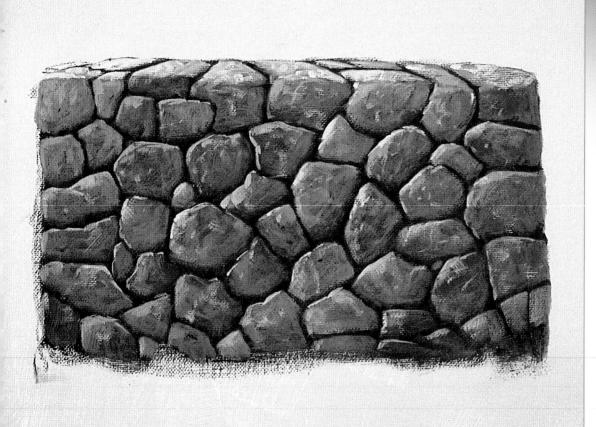

Print Legistic State Sealed

C Add Dimension to Stones

Mix white with a touch of Cadmium Orange and thin until very creamy. Load a small amount on a no. 4 flat sable. Because the sunlight is coming down from the left, paint the highlight color on the upper-left side of each stone. Notice how this gives each stone a nice, irregular shape or form. You can scatter this color on the front side of most of the stones to create a more rugged effect.

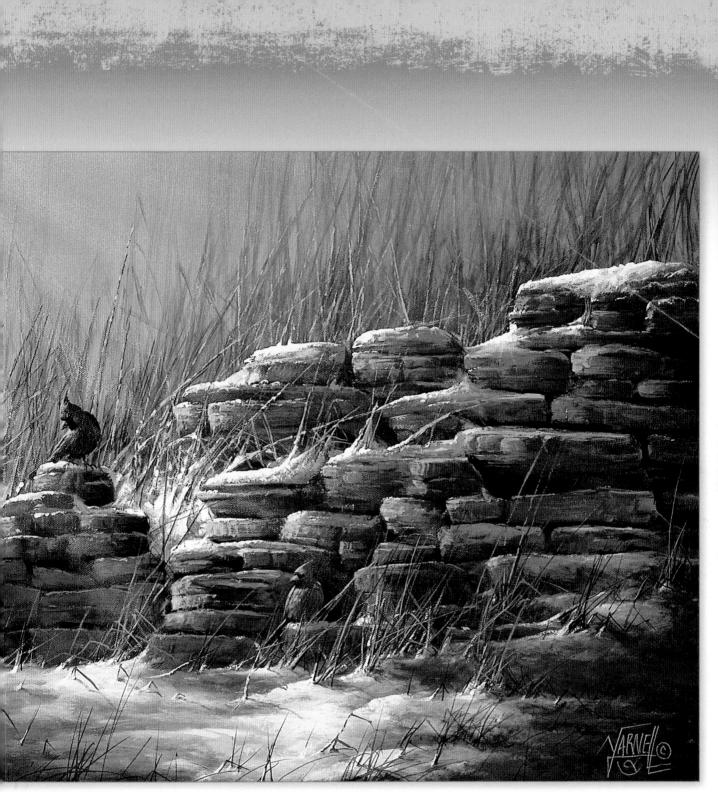

J*ust Chillin'* 18" × 24" (46cm × 61cm)

Apply the Lesson

In the two stone-painting studies in this book (page 38 and this study), I use two layouts. The first is a stone pathway in which the stones lie flat, creating ellipses. The second is this study's stone wall, in which the stones stand vertically on their sides and you can see the entire face of each stone.

In this finished painting I painted a stone wall I built right outside my studio. This wall was built for a pond and waterfall, so the stones are lying flat. You can see only their edges because they are stacked on top of each other, but the technique I used to create those edges is the same technique I used for stones facing you.

THUMBNAIL STUDY

Rocks

I love to paint rocks, but after many years of teaching, I've discovered that most students struggle with this subject. Rocks are very common in many landscapes and can add unique interest to a composition. While there are many different kinds of rocks, the basic concept used to paint them remains the same, so don't be afraid.

Underpaint Rocks

You won't need to premix any color here because you will be doing all your mixing on the canvas. Start by double or triple loading your no. 6 bristle brush with Burnt Sienna, Ultramarine Blue and a little Dioxazine Purple. Scumble all these colors together in a mottled fashion. Add small touches of white as you go to create various middle-tone values. Don't overblend, or everything will become one color or value. You want to leave brushstrokes and some texture.

Highlight Rocks: Phase 1

This first highlight is made by adding a little white and a touch of Cadmium Orange to the underpainting color created in step 1. This should create a shade about two values lighter than the underpainting. Make the mixture very creamy and load a small amount on a no. 4 bristle. Because the light source is from the right side, carefully scrub this highlight on the top-right side of the rock formation. Leave interesting pockets of negative space. Be sure to leave some of the background showing through so the rocks will have good three-dimensional forms.

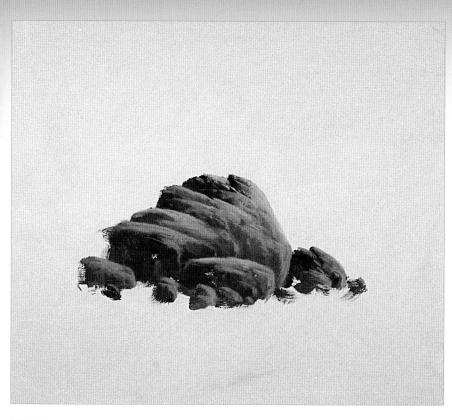

Highlight Rocks: Phase 2

Add a little more white and a little more Cadmium Orange to your highlight color to create a value about three values brighter than in step 2. Make this color very creamy and load a small amount on your no. 4 bristle. Re-highlight everything you highlighted in step 2.

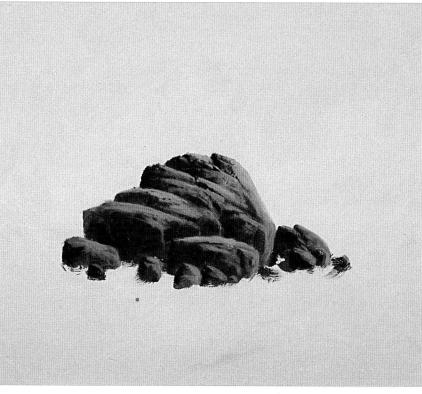

Form Shadows

By now, there's a good chance that you may have overhighlighted or painted out too much negative space. This step will help you reestablish any negative space you may have lost. Take some of the underpainting color from step 1 and use a no. 4 bristle to paint back in some of the darker areas that you may have lost. This is a good time to restructure any rock you need to change.

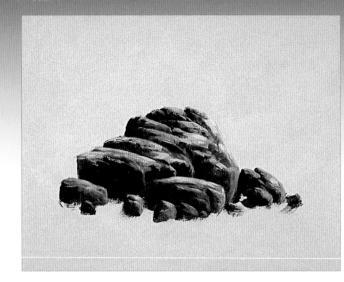

Highlight Rocks: Phase 3

Switch to a no. 4 flat sable. Create a mixture of white with a slight touch of Cadmium Orange and Cadmium Yellow Light. This should be a nice, bright highlight color. It's important that this mixture is very creamy. Load a very small amount on your brush and carefully rehighlight the highlighted areas. Use short, choppy strokes to help create a little texture. Once again, be careful not to overhighlight. If you do, go back to step 4 and add a few more dark areas of shadows.

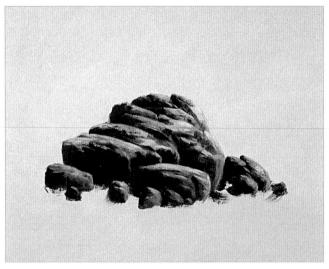

Add Reflected Highlights

This step gives the rocks a more three-dimensional shape. Reflected highlights are used on any object that needs to look more rounded.

Mix one part white + one part Ultramarine Blue + about one-fourth part Dioxazine Purple. Load a small amount of color on a no. 4 flat sable and carefully paint the back side of the rock formations. Carefully blend the color across until it fades into the shadow. This is very easy to overdo, so be careful not to use too much paint.

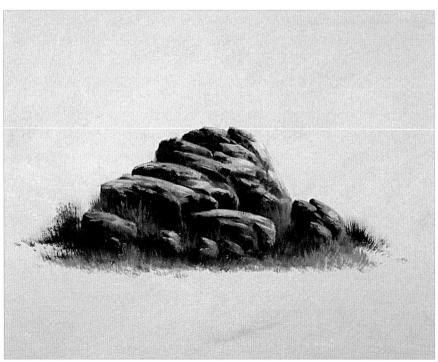

🍸 Add Grass at Base of Rocks

This step simply makes the rocks appear more settled in the landscape. Doubleload a no. 6 bristle with Thalo Yellow-Green and a little bit of Hooker's Green. Start at the base of the rock formations and pull up some clumps of grass to various heights. Do not be afraid to add more color and adjust the values to create more dark and light areas.

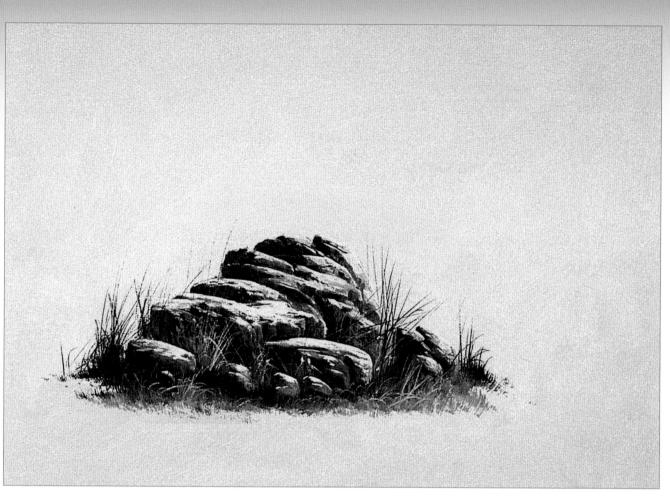

8 Add Final Details and Highlights

• Add some taller weeds and a few brighter highlights on the rocks. You also could add a few cracks and crevices to create more detail. For taller weeds, create very inky mixtures of a light color and a dark color and then use your no. 4 script liner to paint them in.

For the final brighter highlights on the rocks, use white with a touch of Cadmium Yellow Light or a touch of Cadmium Orange or both. Then use a no. 4 flat sable to apply the highlight on the very top edges of the rocks. If you need to add a few darker cracks, use the original underpainting value you used in step 1. THUMBNAIL STUDY Froded Banks

Erosion may be a real problem for some landowners, but it can be a great inspiration to an artist. If handled correctly, eroded banks and dirt cliffs can be a wonderful compositional asset to any painting. Banks and cliffs are not easy; their shape is rough and irregular, but they must flow gracefully and naturally into the rest of the landscape. I'll show you how to create these great land formations so they become an asset to your painting—not an eyesore.

Create Basic Sketch

Draw a very rough sketch of the banks' simple shape. The banks will change some when you paint them, so don't spend too much time trying to make them perfect.

🅤 Underpaint Banks

Create a warm, dark mixture of one part Burnt Sienna + one-fourth part Dioxazine Purple + one-fourth part Burnt Umber. Block in the shape of the banks with a no. 6 bristle using long comma strokes. As you reach the bottoms of the banks, make your strokes more choppy and horizontal. Be sure the canvas is well covered.

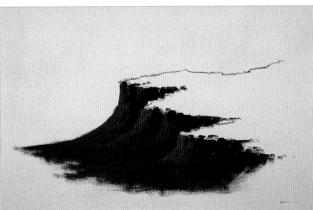

👢 Highlight Banks: Phase 1

Mix one part Burnt Sienna + one-fourth part Cadmium Yellow Light + about one-eighth part white. This should create a soft, warm tan. Make the mixture very creamy. Pick up the color with a no. 4 bristle and highlight the edges of the banks with short, choppy strokes. This particular highlight should not be too bright; its only purpose is to help create the form of each of the banks, so don't overload your brush. You may also need to thin the mixture a bit more so some of the background will show through the highlights.

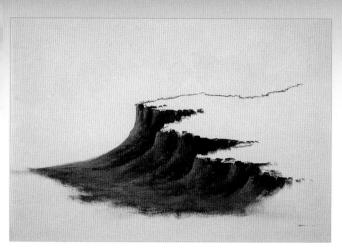

Highlight Banks: Phase 2

Add a touch of Cadmium Orange to white to create a great highlight color. Make this mixture creamy and highlight the banks again, using short, choppy strokes. Allow some of the background to come through to create the illusion of rough dirt. Do not over highlight! If you do, take some of the original underpainting color and paint out that section. Then start the highlight process over, using a no. 4 bristle.

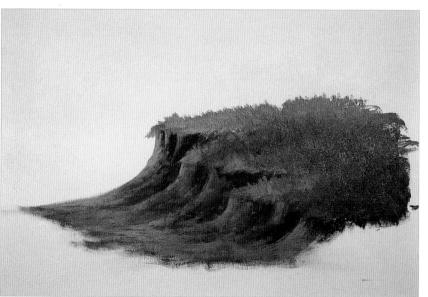

Underpaint Grass

Pick up Hooker's Green with touches of Burnt Sienna and Dioxazine Purple and scrub across the top of the banks. Add a little Thalo Yellow-Green (or Brilliant Yellow-Green) and scumble all these colors together. While this is still wet. take a no. 10 bristle and, with the bristles flat against the canvas, begin pushing upward, starting at the back of the grass area and gradually come forward. When you get to the edges of the banks, pull the grass over the edges. This will help tie the banks and grass together.

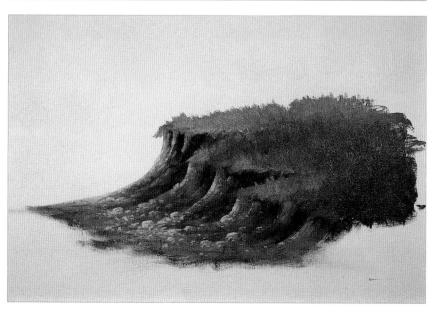

Detail Banks

G Use the highlight color from step 4 (white + a touch of Cadmium Orange) and a no. 4 flat sable to paint in small pebbles along the base of the banks. You can put some of these pebbles against the sides of the banks, but most should go at the very bottom and in the flat area of the dirt. Be sure to create a nice variety of shapes and sizes to make the banks more interesting.

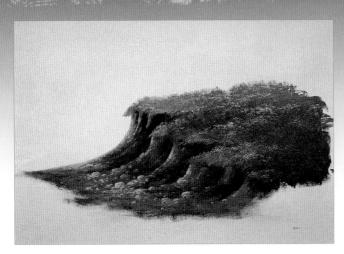

🛛 Highlight Grass

My favorite highlight color for grass is Thalo Yellow-Green + a touch of Cadmium Orange + a touch of Hooker's Green. Make the mixture creamy and load the very tip of a no. 10 or no. 6 bristle. Dab the highlight on the grass, creating interesting pockets of negative space. You will add final highlights later, so just try to give the grass a little texture and three-dimensional feel in this step.

📿 Detail Grass

You can use all your artistic license here. Mix your favorite brighter colors and use a no. 6 or no. 4 bristle to dab on these various highlights. This creates more interest and adds dimension to the grass area. Once again, be careful not to overdo it.

Create a very light mixture of Thalo Yellow-Green + a touch of white. Then create a dark mixture of Hooker's Green + a touch of Dioxazine Purple. Thin both of these mixtures to a very inky consistency. Using these mixtures, take a no. 4 script liner and paint some taller weeds both standing and hanging over the banks.

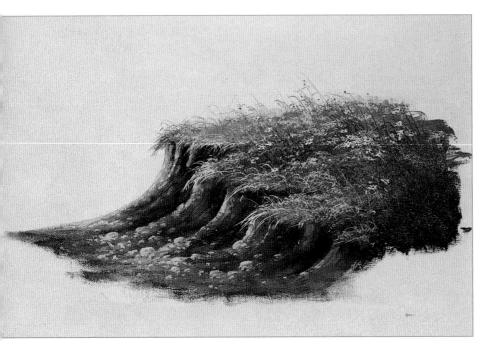

🕽 Add Final Details and Highlights

The white daisies are created using nothing more than pure white applied with a no. 4 round sable. Paint some small petals and then dab the small orange centers. To suggest wildflowers, pick up some pure color on a no. 4 bristle. The colors could be Cadmium Red Light, Cadmium Yellow Light, Cadmium Orange, a pink mixture, or any of your favorite colors.

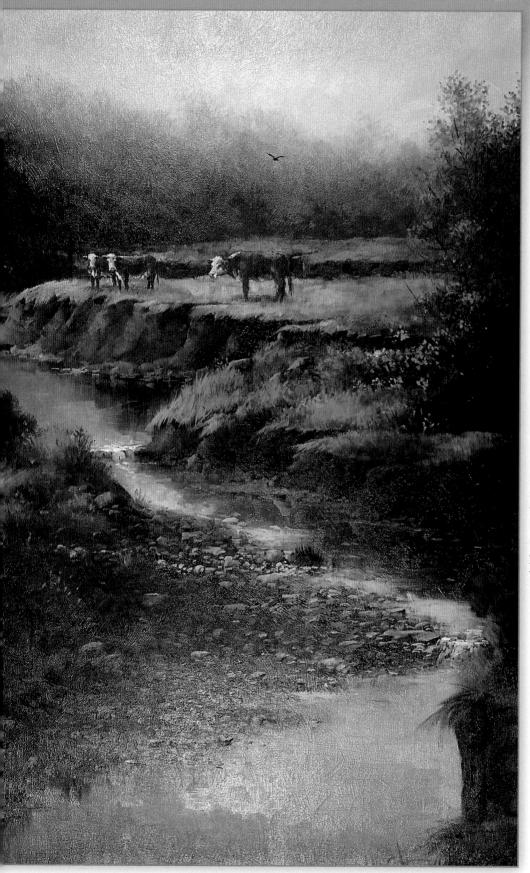

Apply the Lesson

I thought you might enjoy seeing what you can do with eroded banks within a complete painting. The terrain close to my studio inspired me to paint A Creek Runs Through It. The eroded banks are what caught my eye. Though it may seem odd, these banks are the main interest in the painting, as well as the main compositional asset, so I suggest you really spend some time learning how to create them. You never know when they may end up being the very object you need to create a beautiful composition.

a Creek Runs Through It 22" × 28" (55cm × 71cm)

THUMBNAIL STUDY

Ocean Waves

I don't live near the ocean, and maybe you don't either. However, I highly recommend this study, even if you do not want to paint seascapes. This study contains many great instructional techniques that will, no doubt, help you in other areas of your painting. Please don't shy away from this one. It's a bit challenging, but the end result can be outstanding, and the satisfaction of knowing you did it will really build your confidence. Let's get to work!

Create Basic Sketch

Take your no. 2 soft vine charcoal and roughly sketch the main components of the seascape. You don't need great accuracy.

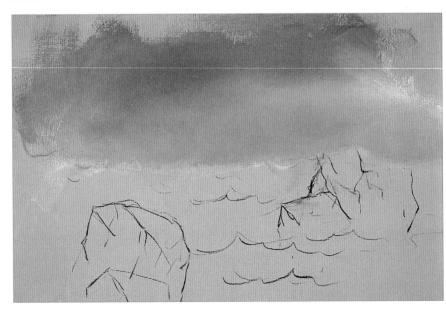

) Paint Sky

Create a very creamy mixture of white + a touch of Cadmium Orange and Cadmium Red Light. Paint the entire sky area with a hake brush. While it's still wet, start at the top and add touches of Ultramarine Blue, Burnt Sienna (to turn it gray) and a touch of Dioxazine Purple (optional). Blend the colors downward, using large "X" strokes. Be careful not to blend too far down, or you will loose the nice, soft, peachy horizon. This is where the "three P's" apply: don't piddle, play or putter.

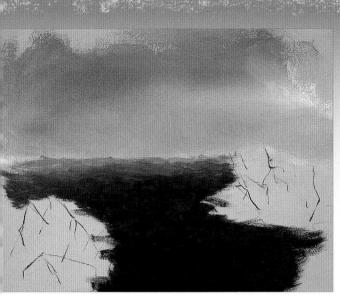

Underpaint Water

For the water, create a creamy, dark bluish green mixture from one part Ultramarine Blue + one-fourth part Hooker's Green + a touch of Dioxazine Purple. Begin applying the color with a no. 6 bristle using short, choppy, horizontal strokes. You want this to be very choppy, so don't be afraid to apply the paint fairly thickly, and remember to leave brushstrokes. Notice that at the horizon, the water is a little bit lighter. To achieve this look, add touches of white to the dark underpainting color as you recede into the background. This establishes gradual value changes from the darker foreground to the lighter background.

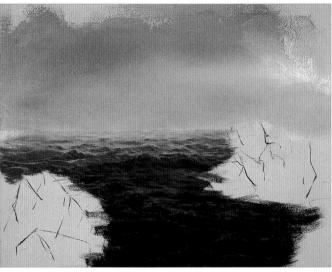

Highlight Water: Phase 1

This is where the challenge begins. First, take the dark mixture you used in step 3 and add white to lighten the value by about three shades. Make this mixture so creamy it is almost soupy. Load a small amount on the end of the bristles of a no. 4 flat sable. While holding the bristles horizontally to the canvas, begin making short, irregular, horizontal strokes, creating interesting pockets of negative space.

The challenge is to create good eye flow based on how you arrange the pockets of negative space. If you aren't careful, all the pockets of negative space will end up the same size and shape. Remember, this is moving water, so there will be very little symmetry in the shapes that the water creates.

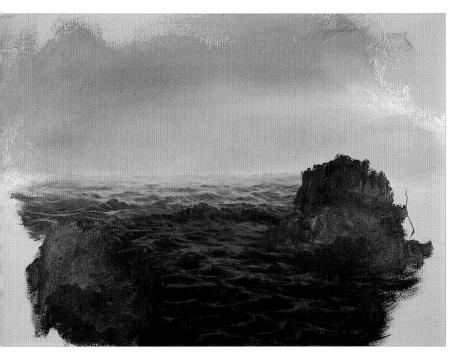

🛫 Underpaint Rocks

With a no. 6 bristle, pick up a little Burnt Sienna, a little Ultramarine Blue and a touch of Dioxazine Purple. Mottle these colors together on the canvas, filling all of the area where the rocks are. You can add touches of white to these mottled colors to make a few subtle value changes. It's OK to see lots of brushstrokes and to apply the paint thickly.

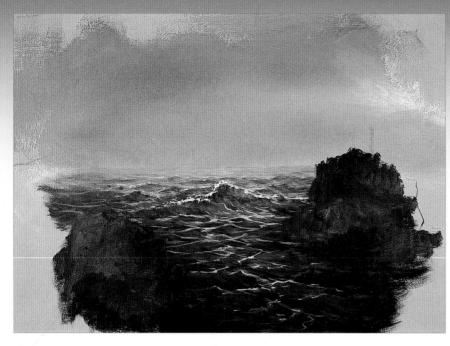

Highlight Water: Phase 2 Create a mixture of white with a slight touch of Ultramarine Blue to create a light bluish tint. Thin it to a very creamy consistency. Load a no. 4 round sable and highlight the ripples of the water. These are really the ridges on the edges of the negative space you created in step 4. This is also a good time to highlight the area on top of and around the main wave in the center.

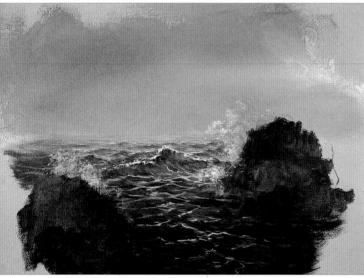

7 Add Splashes Behind Rocks

To add the splashes behind the rocks, mix white + a touch of Ultramarine Blue (basically the same mixture you used in step 6). With a no. 4 bristle, scrub this color behind the rocks. It's extremely important that you scrub this on in such a way to create very irregular shapes on the outer edges of the splashes. Be sure the edges are very soft and blended into the background. Usually when you apply an application like this and scrub it out, it will dry a little darker than you want, so don't be afraid to repeat this step a couple times to get it as bright as it needs to be.

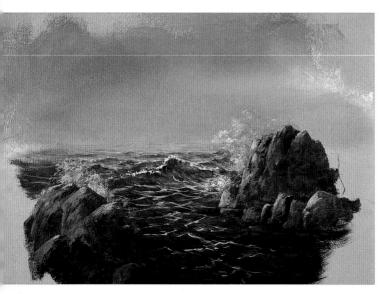

📿 Highlight Rocks

Mix white + a slight touch of Cadmium Orange and Cadmium Yellow Light. Dull this slightly by adding a small touch of Ultramarine Blue (this is called graying a color). Load a small amount on your no. 4 or no. 6 bristle. Keep in mind that the light is coming from the left side. Begin highlighting the rocks using short, choppy, vertical strokes that follow the contour of the rock formations. As usual, be careful not to cover up too much of the underpainting and not to clog up all the pockets of negative space. If you do, the rocks will lose their three-dimensional forms.

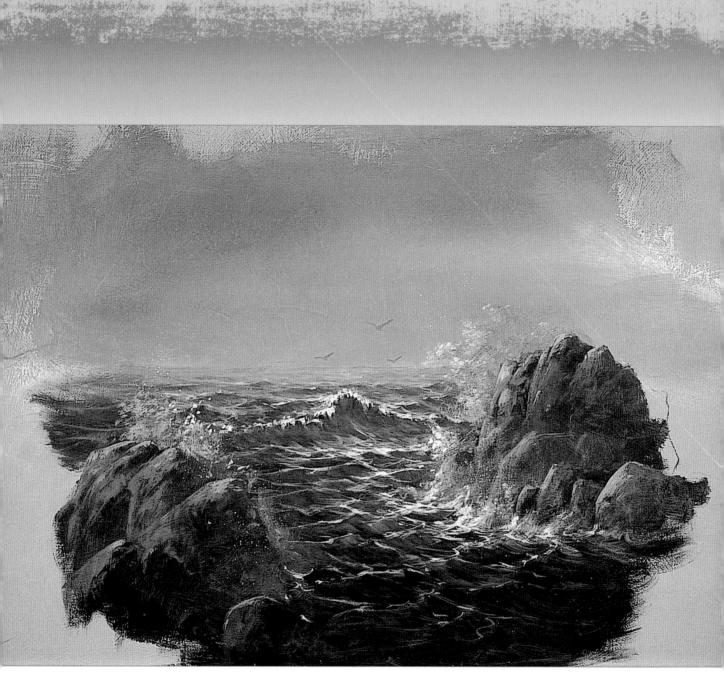

🕽 Add Final Highlights

Add water to pure white paint until it is very creamy, almost souplike. Load a toothbrush and spatter the areas around the splashes to suggest mist. This is the same technique we use for creating pebbles and snow (see pages 31, 37 and 103). Be careful not to overspatter the painting. Take pure white with your no. 4 bristle and smudge in the suggestion of splashes against the fronts of the rocks where the waves have crashed into them.

Now, it is simply a matter of rehighlighting any area you feel needs more light.

THUMBNAIL STUDY

Running Water

Running water is one of the more fascinating components of a landscape. It adds interest, action and good entry into a painting, and streams and rivers often serve as the main center of interest. As appealing as running water can be in a landscape, if not done correctly, it can be more of a distraction than an asset. My goal is to teach you some techniques to help you add this running water to any landscape and make it look professional, eye-appealing and compositionally correct.

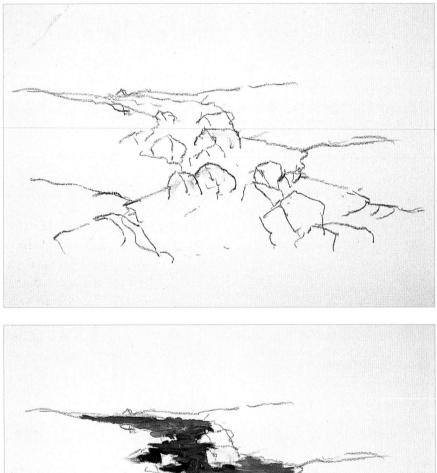

Create Basic Sketch

With a no. 2 soft vine charcoal, draw a quick, rough sketch of the basic layout of the stream. The sketch need not be accurate in the details, because shapes, forms and ground formations will change as you begin to paint.

adds to the movement of the water.

2 Underpaint Stream Bed Create a very dark bluish green mixture of one part Ultramarine Blue + one-fourth part Hooker's Green and then divide it into two piles. To one pile, add about one-fourth as much white to create a lighter value. With a no. 4 bristle and the lighter value, paint in the back half of the stream using short, choppy, horizontal strokes. As you come forward, begin adding the darker mixture (from the second pile) using the same strokes. It's fine if the water looks choppy—this

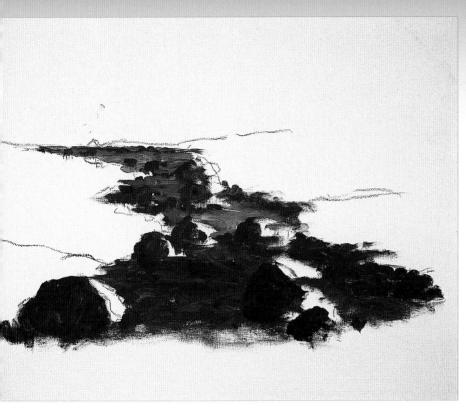

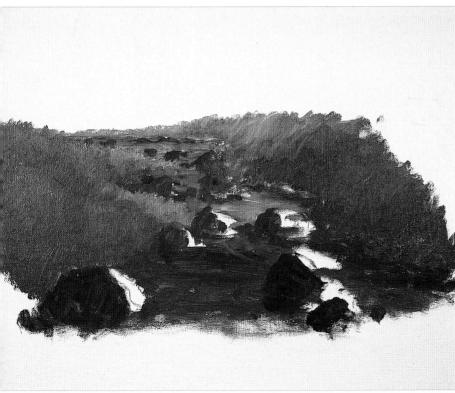

Underpaint Rocks

Create a very dark mix of one part Burnt Sienna + one-fourth part Ultramarine Blue + a touch of Dioxazine Purple. Underpaint each rock with a no. 4 or no. 6 bristle. Again, it's OK for brushstrokes to show, in order to give the rocks a little texture. Remember, you want a wide variety of shapes and sizes.

Underpaint Grass This type of grass is used in earlier studies, so you should be familiar with it. Starting at the back and on both sides of the stream. paint on Thalo Yellow-Green and touches of Hooker's Green with a no. 10 bristle. Apply the colors fairly thickly and then mottle them together. While the paint is still wet, take your brush and push the color upward, creating a grasslike texture. As you come forward, begin adding more Hooker's Green, Burnt Sienna and touches of Dioxazine Purple to the mixture so it becomes a dark forest green. The paint must be fairly thick in order to leave a texture when you push it up with your brush.

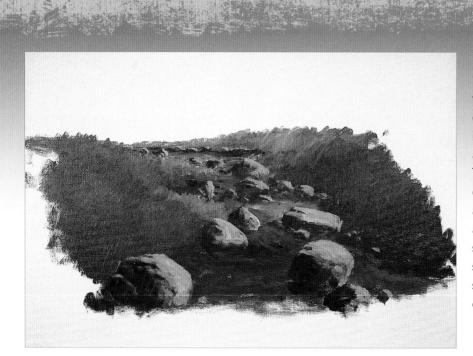

Highlight Rocks: Phase 1 🗧

To create a soft, warm highlight for the rocks, take a little bit of the original rock underpainting color used in step 3, and add half as much white and a touch of Cadmium Orange. This is not the final highlight color, so don't make it too bright. Load a small amount on the tip of a no. 4 bristle and paint a highlight on the top-right side of each rock. Remember to allow some of the underpainting color to show through to create a more threedimensional look.

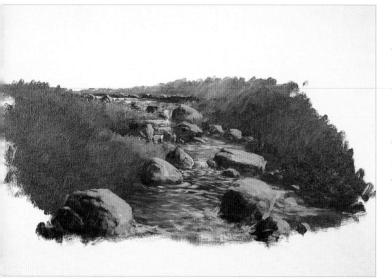

🕆 Highlight Water: Phase 1

This is one of the most important steps to help make the water look as if it's moving. Create a highlight color of one part Ultramarine Blue + one part white + about one-eighth part Hooker's Green. Take a little bit of the mixture and thin it to a very, very creamy consistency. Then load a small amount on the tip of a no. 4 flat sable. Hold the brush horizontal to the canvas and apply the highlight color using short, choppy, horizontal strokes. Notice that the strokes are very irregular, with interesting pockets of negative space. Be very careful not to overhighlight and, as a result, cover up too much background.

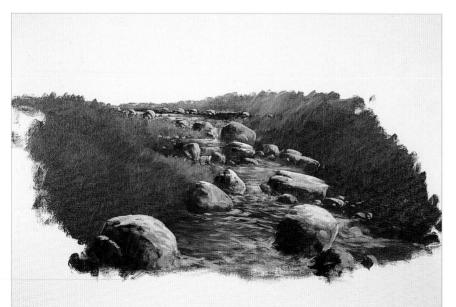

🎢 Highlight Rocks: Phase 2

This step brightens the rocks. I have a fairly standard highlight color I use for most rocks. Mix white with a slight touch of Cadmium Orange; you could add a touch of Cadmium Yellow Light to create more of a golden tint. Make this mixture very creamy. Load a small amount on the tip of a no. 4 flat sable and carefully apply this color on the areas that have already been highlighted, but still allow some of the underpainting to show through. Use short, choppy strokes to create texture.

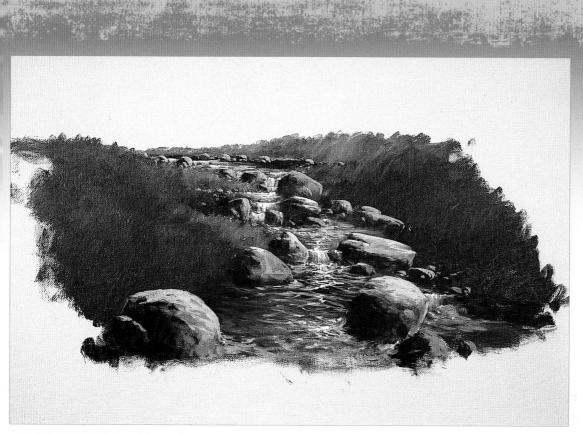

📿 Highlight Water: Phase 2

This is a simple but important step. Add a very small touch of Cadmium Yellow Light to white to create a whitish yellow tint. Keep in mind you are not creating a color but rather a tint. Make the mixture extremely creamy. Put a somewhat heavy load on a no. 4 round sable and apply these highlights to the center areas of the water where it moves around the rocks and on the small waterfalls. This highlight needs to stay very clean and bright as well as very opaque, so reload your brush often. Don't be afraid to repeat this step one or two more times in certain areas to be sure you get it as bright as you need it.

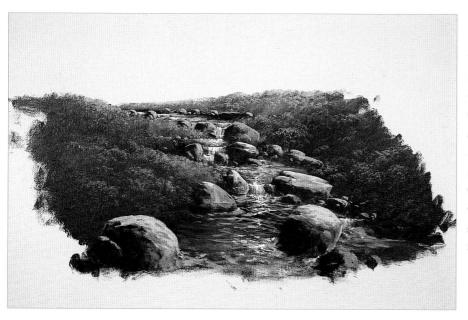

🔪 Highlight Grass

Create a creamy mixture of Thalo Yellow-Green + a touch of Cadmium Orange. This creates a very nice, soft hue similar to a mustard color. Load the very tip of a no. 6 bristle and dab the color onto the grassy areas, following the contour of the land as it goes in toward the water. As always, be sure you create very interesting pockets of negative space so your eye flows gracefully around the grassy areas.

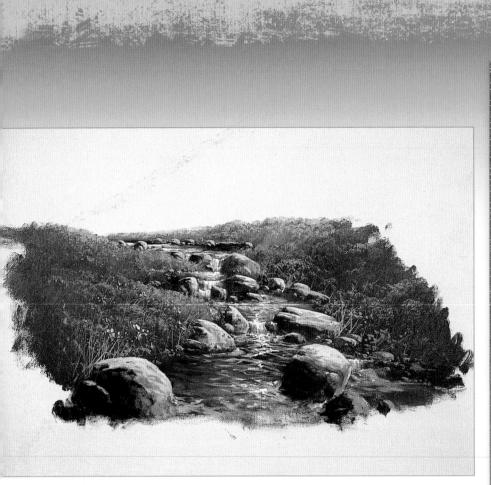

/ 🦳 Add Final Details and Highlights

What you do in this step is really up to you. You can dab on a few bright, miscellaneous flowers of any color you choose. You can use your no. 4 script liner to create a couple light and dark inky mixtures and use them to add some taller weeds, especially toward the front of the stream. You may want to highlight your rocks a little brighter and also brighten the highlights on the water.

Peaceful Waters 12" × 16" (30cm × 41cm)

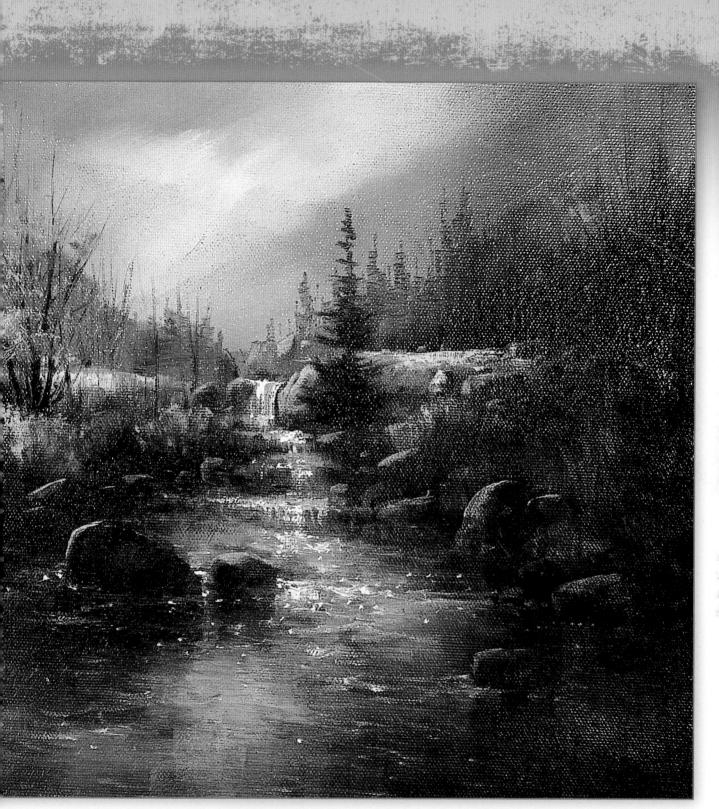

Apply the Lesson

There are many different ways to apply and use this study on running water. In a work of art, running water need not be turbulent or crashing over boulders to seem lively. The painting you see here, *Peaceful Waters*, was a small plein air painting done in oil. (*Plein air* means the painting was done outdoors and on location.) In this painting, the water is a gently moving stream with just enough ripples to create a peaceful, relaxing atmosphere. The technique we use in this study is the same used in this lovely plein air piece.

THUMBNAIL STUDY

Reflections in Water

Reflections are necessary in any landscape containing still water. However, learning how to paint reflections is, by far, one of the more challenging techniques in landscape painting. The process is really quite simple, but students tend to make it more complicated than it needs to be. This is a very simple study, designed only to show technique. The technique applies to any calm water you may add to your paintings. The real challenge is making the reflections appear very wet.

Create Basic Sketch

Use your no. 2 soft vine charcoal to draw a very rough, simple sketch of the main components of the landscape. Locate the horizon line.

Underpaint Sky and Water

We paint the sky and water at the same time because the water must have a hue similar to the sky. Mix white with a touch of Cadmium Orange to create a soft, very creamy horizon color. With a hake brush, paint this color about halfway up the sky and halfway down in the water using large "X" strokes. While the horizon color is still wet, mix white with a touch of Ultramarine Blue. Quickly use your hake brush to blend this color from the top of the sky down into the peach-colored horizon. Do this same thing in the water, but go from the bottom upward. Be sure everything is blended very softly.

👤 Underpaint Background

Make a soft, mauve gray from white + touches of Dioxazine Purple, Ultramarine Blue and Burnt Sienna (it will need to be a value about two shades darker than the horizon). Use a no. 4 bristle to paint in the background mountain.

Darken the mixture by adding a little Hooker's Green and a touch of Dioxazine Purple. This should be a grayish green about two shades darker than the background. Paint in the midground trees and mountain. Be sure you keep the edges very soft.

Underpaint Reflections

For these refections, add a little white to the colors used in step 3 to slightly lighten the value and make it very creamy. Load a very small amount on a no. 4 bristle and scrub in the basic shape of the trees and mountains. The mixture has to be just the right consistency for this to work properly, so you may need to experiment a little bit. As before, it's very important to make the edges of the reflections very soft.

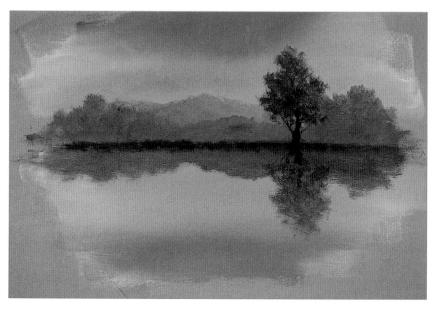

🛫 Paint Shoreline and Tree

To smudge in a dark underpainting for the shoreline, darken the color you used in step 4 by adding a little more Burnt Sienna, Hooker's Green and Dioxazine Purple. Scrub this color on the shore with a no. 4 bristle. Keep the edges very soft.

Use this same color and a no. 4 round sable to paint the tree trunk and its reflection. For the tree's foliage, add a little white to this same mix to slightly lighten it. Add a little Hooker's Green to create a grayish green. Use a no. 4 bristle to scrub in the foliage and the reflection. Be sure the reflection is very, very soft.

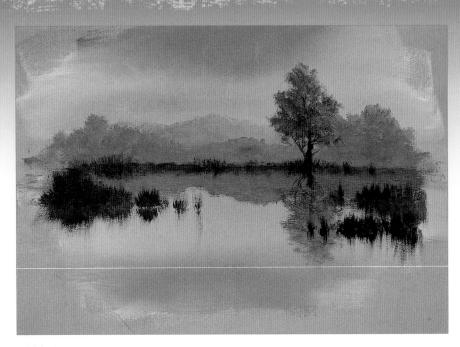

Add Clumps of Grass

Darken the mixture used for the tree in step 5 by adding a little more Hooker's Green and a touch of Dioxazine Purple. Load a small amount on the tip of a no. 4 bristle. Decide where you want to place grass clumps and place the brush vertical to the canvas. Pull up with short, vertical strokes, creating the suggestion of grass. After you pull up, immediately pull downward with the same stroke to create the reflection.

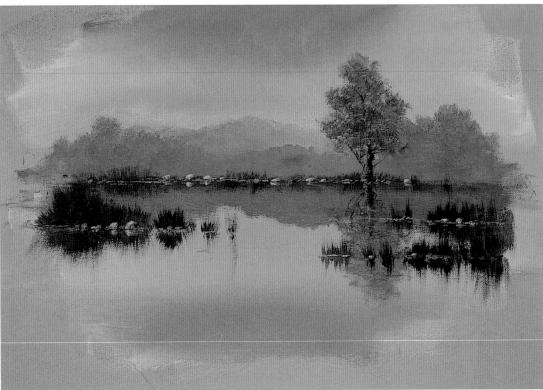

7 Highlight Shoreline and Trees

To suggest rocks along the shoreline, mix white with a touch of Cadmium Orange and dull it down a bit with a little Ultramarine Blue. Load a very small amount on a no. 4 flat sable and paint along the shoreline using short, choppy, broken strokes. Do this also at the bases of the clumps of grass. Make a few larger smudges to create some slightly larger rocks.

Mix Thalo Yellow-Green + a touch of Cadmium Orange. With a no. 4 bristle, dab a few highlights on the left sides of the tree leaves to create a little more form. Do this on the background trees and their reflections, as well.

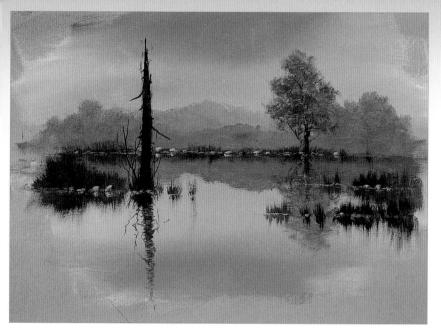

🔿 Paint Dead Stump and Reflection

This stump is another opportunity to add a reflection to the water, so keep it simple. Mix one part Burnt Sienna + one part Ultramarine Blue. With a no. 4 flat sable, underpaint the stump, using short, choppy, vertical strokes.

Slightly lighten the value with a little white. Load a no. 4 flat sable and use short, horizontal strokes to paint in the reflection. The reflection should have a bit of a blurry appearance, and it should not be painted on too solidly. Let a little of the background water show through.

🔵 Add Final Details

First, highlight the dead tree and the trunk of the live tree. Mix white + a touch of Cadmium Orange. Load a no. 4 round sable and use short, choppy strokes to create the highlight and barklike texture on the left side of the dead tree. Don't forget to highlight the reflection and to put a little highlight on the trunk of the live tree.

Mix a little Hooker's Green + Dioxazine Purple and thin it to an inklike consistency. Load a no. 4 script liner and paint in some tall weeds around the grass clumps. Then paint the reflections of the weeds in the water.

You also can add miscellaneous details and highlights to suit your own personality. For instance, you can highlight the clumps of grass, highlight the middle background, add birds, etc.

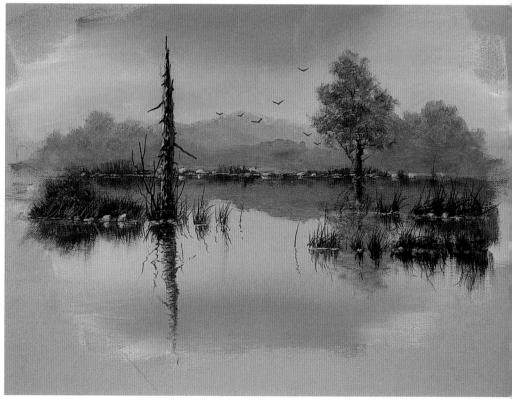

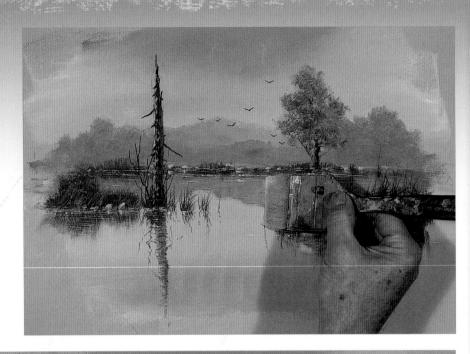

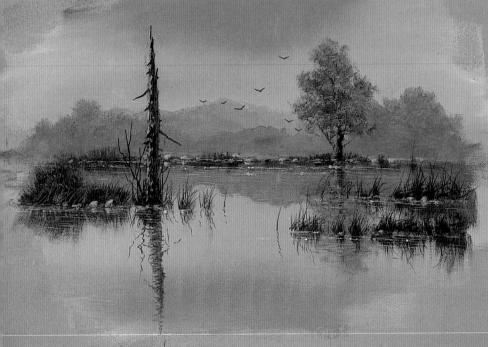

torina - attender the with the same of the state

🕤 Glaze and Highlight Water

Create a very thin wash of water and a little bit of pure white. Load the very chisel edge of a hake brush and turn it vertically to the canvas. Lightly touch the canvas then slightly wiggle your brush up and down as you drag it sideways across the surface of the water. The top photo shows this in progress. Wiggling will create a slightly rippled effect and soften any reflections that are too dark.

Load a no. 4 round sable and paint some short, choppy, horizontal strokes along the shoreline and the bases of your clumps of grass. This creates the suggestion of ripples and helps separate the water from the ground.

The bottom photo shows the finished study.

Peace Be/Still 12" × 16" (30cm × 41cm)

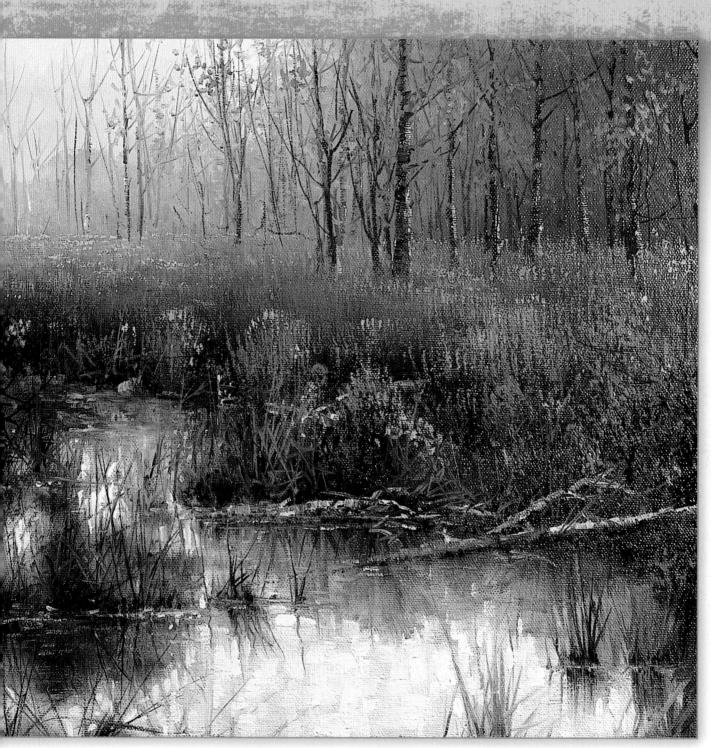

Apply the Lesson

This study of reflections mostly concentrates on a very simple application in a clear, calm body of water, but there are many different applications for this technique—even the mud-puddles study (page 70) shows another application.

I thought it might be fun to show you a finished painting that includes this refection technique. This painting, *Peace Be Still*, is a swamp scene that caught my eye one day as I was on a research trip. Not only were the flowers really spectacular, but the reflections interested me the most. I used the same technique that I showed you in this study to create this beautiful, muddy pond.

Mud Puddles

Mud puddles are fun and not too difficult to paint. They also can add some terrific interest to certain paintings. This is a great lesson on how to make water appear wetter in your painting. My favorite application for puddles is to put them in dirt roads. However, you can use mud puddles almost anywhere you have a dirt background.

Underpaint Dirt

Create a soft, warm, mottled background with a no. 10 bristle and Burnt Sienna, Burnt Umber and a little Dioxazine Purple. Begin blending these colors on the canvas using long, vertical strokes. As you blend these colors, add touches of white while the paint is still wet to create various very subtle value changes. Do not overblend this background.

🕥 Highlight Dirt

Lighten the underpainting color from step 1 by about three shades by adding some white. Thin it, making the mixture very creamy. Load a small amount on your no. 10 bristle. Begin scrubbing on some highlights, creating the suggestion of rough dirt. The key is not to overpaint. As usual, you should allow some of the background to show through to create some interesting pockets of negative space.

Spatter Pebbles

Refer to the study on creating pebbles and dirt (page 30) to create pebbles with a toothbrush. You can follow that study exactly, but you may want to use different colors for this study. Be sure to create a good variety of lights and darks.

Underpaint Puddles

Mix one part Ultramarine Blue + one-fourth part white + a touch of Burnt Sienna to turn it slightly gray. Don't add too much Burnt Sienna, because you need a very bluish gray. With a no. 4 or no. 6 bristle, scrub various shapes of puddles throughout the background. As you scrub, be sure you blend the edges into the background so there are no hard edges.

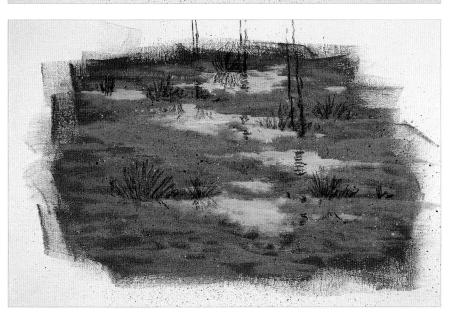

5 Sketch Clumps of Grass and Fence Posts

Use a no. 2 soft vine charcoal to sketch in the posts and clumps of grass. Though this is just a study, you want to be sure you have a nice compositional arrangement of the objects.

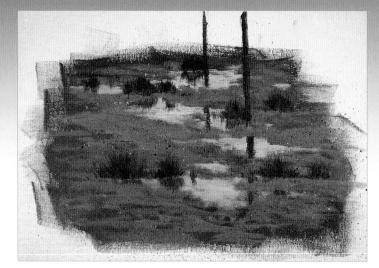

Paint Clumps of Grass and Fence Posts

For the clumps of grass, mix a deep olive green from Hooker's Green + a touch of Burnt Sienna and Dioxazine Purple. Use a no. 6 bristle to pull upward, creating a soft, grassy effect. At the same time, also pull downward to create the reflection. Be sure your strokes are quick and decisive.

Use pure Burnt Umber to paint in the fence posts, and also their reflections at the same time, with the same upward and downward motion.

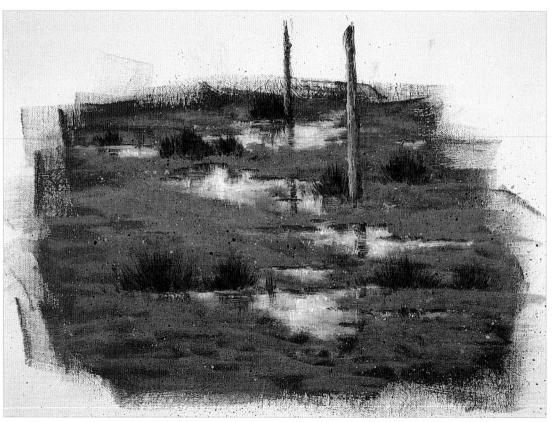

7 Highlight Puddles and Posts

First highlight the fence posts with a mixture of white + a touch of Cadmium Orange and a no. 4 round sable. Use short, choppy, vertical strokes to highlight the posts and their reflections at the same time. When you paint in the reflections, use short, choppy, horizontal strokes to suggest rippled water.

To give the puddles a little more form, darken the shoreline on the back side of each puddle. Apply a little Burnt Umber to the darker shoreline edge using a no. 4 flat sable. Keep these shores very soft without any hard edges.

Add water to pure white to make the paint very creamy. Load the end of a no. 4 flat bristle and drybrush across the surface of the water to soften the reflections.

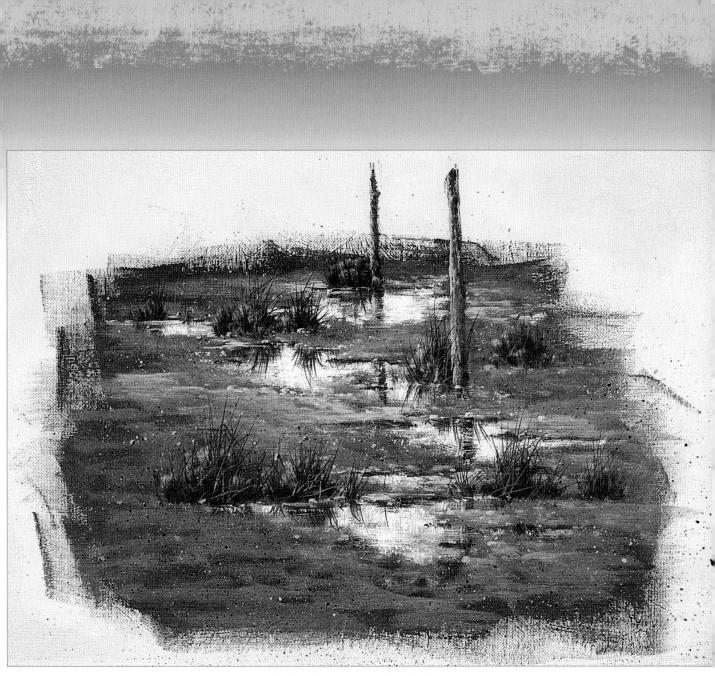

> Add Final Details and Highlights

Add some tall weeds, highlight the dirt and add larger pebbles or any miscellaneous things you feel would make the study more interesting.

For the weeds, create a very inky mixture of the original grass color, load it onto a no. 4 script liner and paint in some tall weeds. Paint in their reflections at the same time. Be sure to slightly wiggle your brush as you paint the reflections to suggest ripples.

Highlight some of the areas around the puddles to create a little more texture and three-dimensional feel to the dirt. Mix white with a touch of Cadmium Orange. Load a small amount on a no. 4 flat sable to brighten a few areas around the puddles. You can also add a few larger pebbles here and there.

Finally, load the very tip of a no. 4 round sable with pure white. Dab a few highlights on the water to give a little sparkle.

THUMBNAIL STUDY

Lightning

Perhaps you will never want to paint lightning in a landscape. As a student, however, it is important to experiment with all kinds of techniques, subjects and mediums. Everything you learn will help you in other areas of your painting. Lightning is beautiful and exciting. It can be included in all kinds of great compositional opportunities and can add tremendous atmosphere to certain paintings.

Paint Background

Stat Man

The main thing a lightning scene needs is a wellmottled, stormy background. Because this is just a study, we will keep it very simple.

Create a dark gray mixture of one part Ultramarine Blue + one-fourth part Burnt Sienna + a touch of Dioxazine Purple. Add just enough white to create a nice medium dark gray. With a hake brush, begin mottling this color on the background. While the sky is still wet, add touches of white to create various light and dark pockets of negative space. Be sure to create one light spot of negative space brighter than any other light spot in the sky; this will be where the lightning originates.

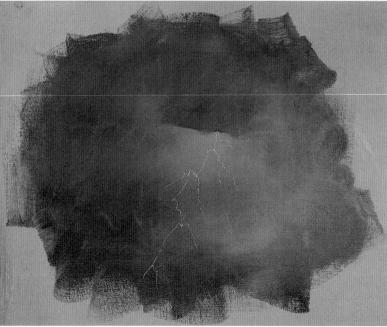

7 Sketch Lightning

Take your white Conté pencil and lightly sketch in the exact shape of the lightning in the exact location. Be sure to sketch very lightly. You can make your lightning any shape you want. You can find great reference material on lightning in books, magazines and, of course, on the Internet.

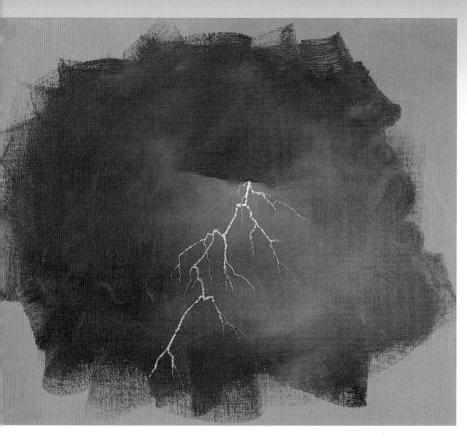

Paint Lightning

Brighten the spot where the lightning is coming from by creating a mixture of white with a touch of Cadmium Yellow Light. Scrub this color at the base of the cloud with a no. 4 bristle. Drybrush outward until you have a nice, bright, soft light area.

Load this color on a no. 4 round sable and paint in the lightning. Use very small, short, sideways strokes. This technique may seem odd, but it will give the lightning a slightly blurred effect.

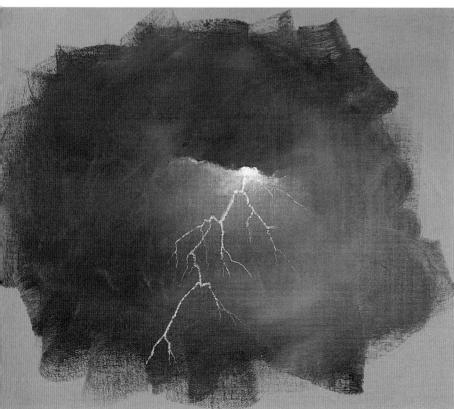

4 Highlight Sky and Add Lightning Flash

Again brighten the light area behind the lightning using the same process you used at the beginning of step 3. Load white, toned with a bit of Cadmium Yellow Light, on a no. 4 round sable and paint in the very bright spot at the source of the lightning. This needs to stay very clean and bright so when you paint it on, don't blend it out too much, or it will lose its brightness.

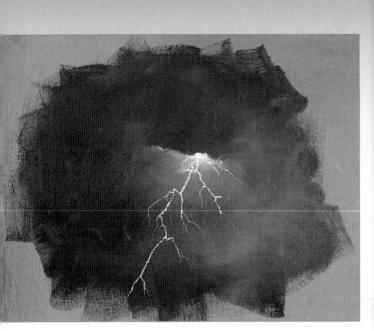

🧲 Brighten Lightning

Use the same whitish yellow mixture from step 4. Add water to it to make it creamy. Dip the point of a no. 4 script liner in the mixture to create a little peak of paint on the tip. Very carefully place this color directly in the center of the lightning, using little, short, choppy strokes. Reload very often so the paint stays clean and bright. This is a very tedious process, so be very patient. If you happen to overhighlight, gently wipe off the paint and start over.

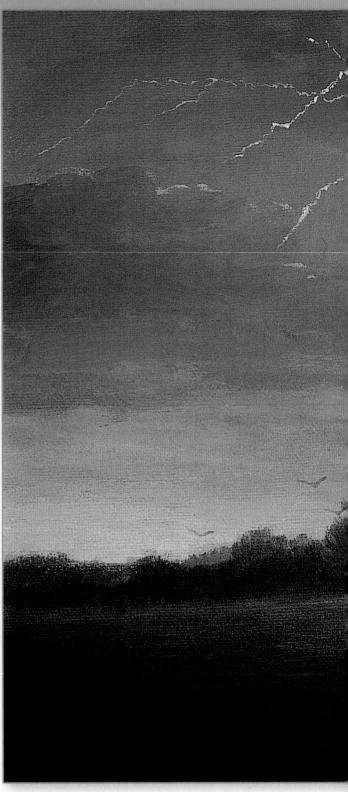

Sara Barrier

Heaven's Warning 10" × 20" (25cm × 51cm)

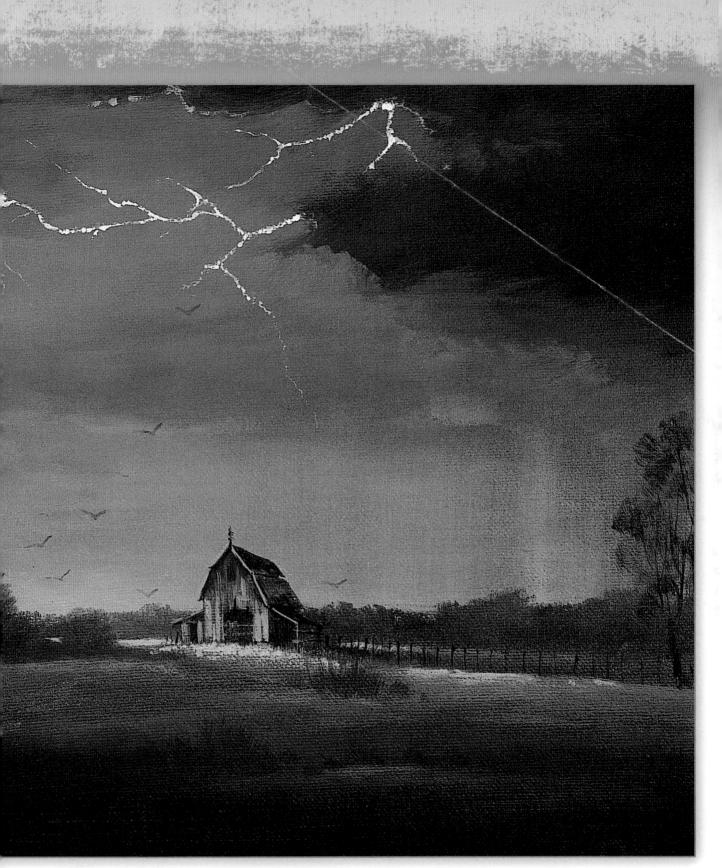

Apply the Lesson

As you can see, the horizontal lightning was just the ticket for this particular painting. I'm sure you have noticed what great drama and atmosphere lightning adds to the entire painting. Also, notice how it really aids the painting's composition.

THUMBNAIL STUDY

Rainbows

There probably isn't a person on the face of the Earth who is not fascinated with rainbows. A rainbow's arch is very difficult to paint and becomes a problem for most artists. Keeping the form correct and making the colors appear transparent can be quite challenging. This study will help you understand the proper way to create an accurate arch and transparent colors. Another benefit of this study is learning how to create an entire landscape to have the proper background to fit the rainbow.

Landscape Secret

Station Station

A soft whitish underpainting will make the colors in your rainbow stand out.

Create Basic Sketch

With a no. 2 soft vine charcoal create a rough sketch of the general layout of the landscape.

) Underpaint Sky

We need to create a semistormy sky in this step, which requires the mottling of several colors. First, mix a basic gray of one part Ultramarine Blue + one-fourth part Burnt Sienna + onefourth part white + about one-eighth part Dioxazine Purple. Next, mix a light pink of white + a touch of Cadmium Red Light.

Load some of the pink mixture on a no. 10 bristle and scrub on this color at the base of the sky. As you work your way up, start adding some of the gray mixture, creating various light and dark values (this will suggest clouds). You can now switch to a no. 6 bristle and create more distinct clouds, if you wish.

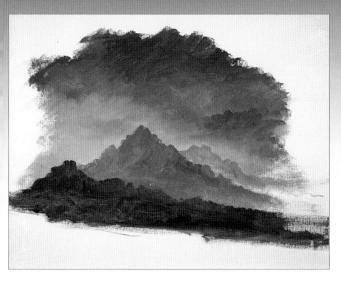

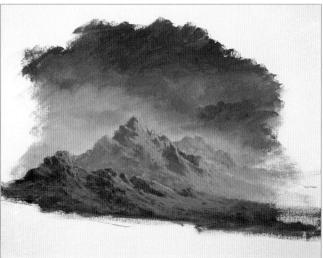

Underpaint Mountains

There are three different values in the mountains. To create these values, add a bit more white and a touch of Dioxazine Purple to the base gray you used in step 2. This is value one. Load this value on a no. 4 bristle and paint in the most distant mountain.

Take the base gray from step 2 and use it pretty much as it is for the midground mountain. However, if it appears too dark, add a touch of white to change the value.

For the foreground mountain, take the base gray and darken it with a little more Ultramarine Blue, Burnt Sienna and Dioxazine Purple.

👔 Highlight Mountains

Create a mixture of white with a touch of Cadmium Orange. The secret to highlighting is how much water you put in the mixture. For the background mountain, thin the mixture so it is fairly transparent, and highlight the right side with a no. 4 flat sable. A more transparent mixture allows the background to show through, thus creating a softer highlight.

For the midground mountain, use less water so the highlight is more opaque. This will make the highlight a little brighter.

Add a touch more Cadmium Orange to the mixture for the foreground mountain's highlight.

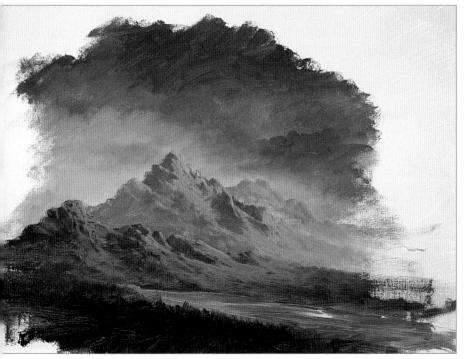

Tuderpaint Foreground 🛫

Mottle Thalo Yellow-Green + a little Hooker's Green on the canvas using long, horizontal strokes. Apply a fairly thick amount of paint to leave a little texture. Don't be afraid to add a touch of Cadmium Yellow Light here and there to create a few bright spots.

In the immediate foreground, mix one part Hooker's Green + one-fourth part Dioxazine Purple + one-fourth part Burnt Sienna. Then take a no. 10 bristle and scrub the mixture in the lower left-hand corner to suggest small bushes and grass. Don't be afraid to put the paint on fairly thickly.

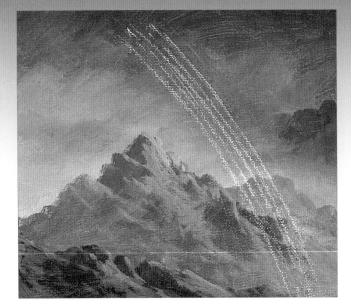

Sketch in Rainbow

Find to an astrony wanted

Once the background is completely dry, use a white Conté pencil to sketch the arch and the width of the rainbow. Sketch very lightly. The Conté pencil wipes off easily with a damp paper towel, so feel free to make several attempts to get it correct.

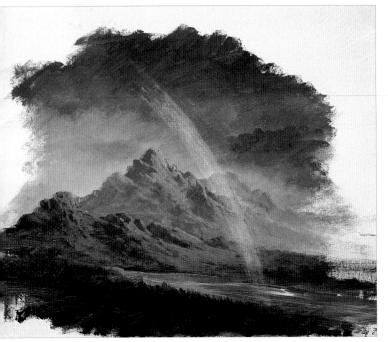

𝕆 Underpaint Rainbo₩

The secret to the colors on the rainbow is to have a soft, whitish background for them. Load a very small amount of gesso on a no. 4 bristle and then wipe off most of it. Following the shape of the sketch, begin drybrushing the gesso on the rainbow, creating a very soft underpainting. It is absolutely critical there are no hard edges on both sides of the rainbow! Carefully feather out the edges.

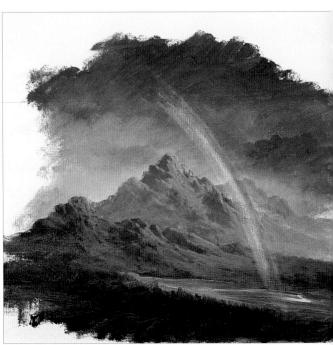

📿 Add Color to Rainbow

• This step uses the same techniques as step 7, but this time you will add actual color. Start on either side of the rainbow (the red side or blue side). Premix the three colors you will be using: Cadmium Red Light + a touch of gesso; Ultramarine Blue + a touch of gesso; and Cadmium Yellow Light + a touch of gesso. Load a very small amount on a no. 4 bristle and carefully drybrush the color on the rainbow using long, sweeping strokes. Be sure you use one continuous stroke for each color. Also, make sure your brush is fairly dry. Repeat this step for each color, being very careful not to leave any hard edges.

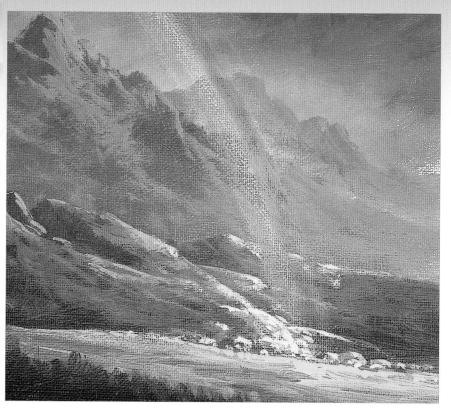

Highlight End of Rainbow and Midground Mountain

Usually there is a splash of bright light on the objects surrounding the rainbow's end. To accomplish this effect, take Thalo Yellow-Green with maybe a little Cadmium Yellow Light and make the grassy area at the end much brighter. Mix white + a touch of Cadmium Orange to highlight the base of the mountain and smaller rocks. A no. 4 bristle works best for these highlights. Make this area as bright as you want; it will add great drama to the painting.

🦳 Brighten Rainbow

Once the paint dries, you probably will need to brighten your rainbow. To do this, repeat the process you used in step 8. Remember to use long, continual, sweeping strokes with very little paint on the brush. Before you brighten, it's probably a good idea to practice on a scrap canvas until you get the hang of it. If you make a mistake, take a little gesso and drybrush over the rainbow. Then start over.

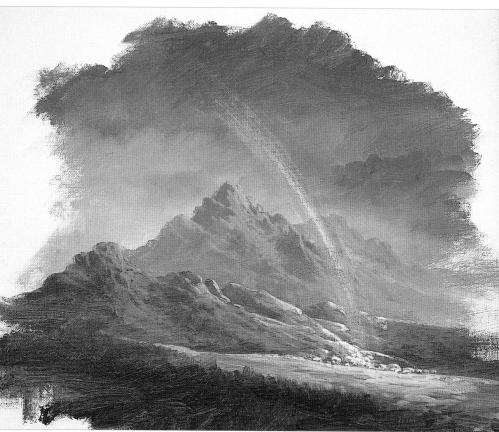

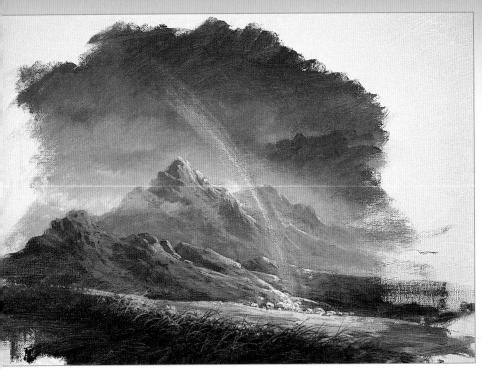

Add Final Details and Highlights

Brighten the area behind the mountain with a no. 4 bristle and a mixture of white with a slight touch of Cadmium Orange and Cadmium Yellow Light. Scrub on the color and feather it out to create a brighter, soft glow.

To add a few tall weeds in the foreground, create a light, inky mixture of Thalo Yellow-Green + a touch of Hooker's Green, and place the weeds wherever you wish. Make a dark mixture of Hooker's Green and a little Dioxazine Purple for the darker weeds.

To finish, dab on a few little wildflowers and just have fun adding whatever details make you happy.

End of the Rainbow 24" × 30" (61cm × 72cm)

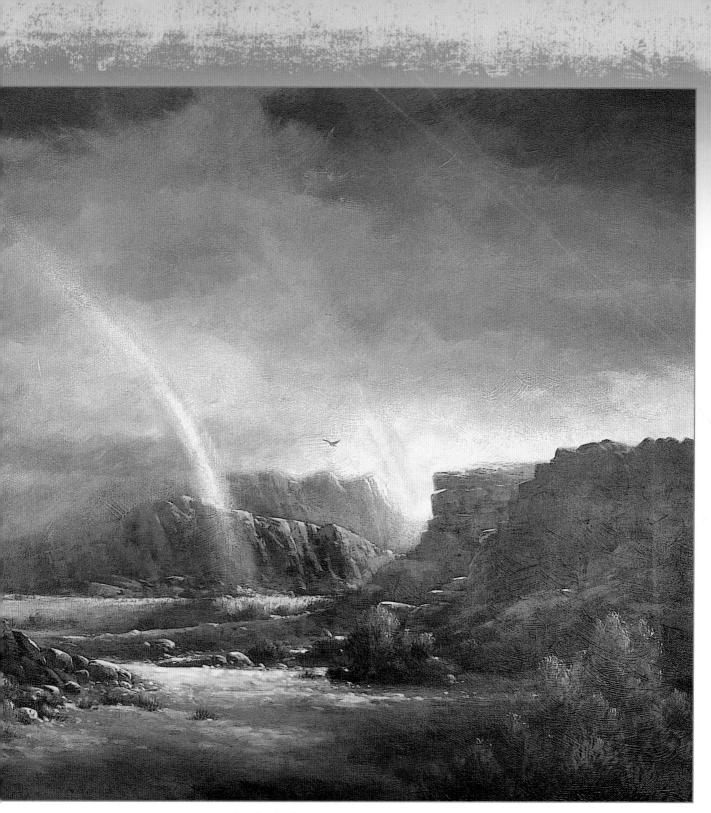

Apply the Lesson

This painting is a great example of how a beautiful rainbow can add tremendous drama and atmosphere. Depending on the composition, it can actually become the center of interest for certain paintings. Rainbows also help add color harmony. THUMBNAIL STUDY

Leafy Trees

For some people, nothing is more pleasing to look at in a painting than a beautiful, leafy tree. Of course, there are all kinds of varieties of trees, and it would be impossible to show all the different types in this book. This study simply teaches a basic technique you can apply to most types of leafy trees; change the size, shape and color to the appropriate type of tree. This technique also works well for small bushes.

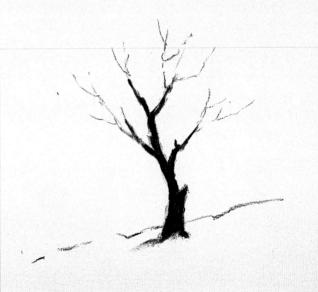

Create Basic Sketch

Use a no. 2 soft vine charcoal to roughly sketch the basic, general shape of the tree.

) Block in Tree Trunk

Add a little water to plain Burnt Umber to make the paint creamier. Load a no. 4 flat sable to block in the basic shape of the trunk. Switch to a no. 4 round sable and add just a few minor limbs. It's important not to add too many limbs at this stage because you will add the final limbs after the tree leaves have been completed.

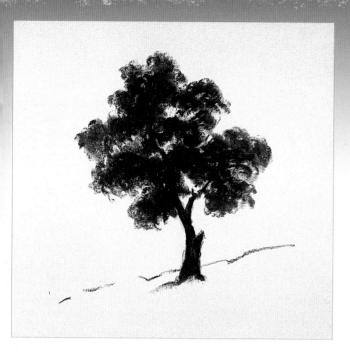

📃 Underpaint Leaves

Create the basic tree color by mixing one part Hooker's Green + one-fourth part Burnt Sienna + about one-eighth part Dioxazine Purple. This should create a very deep, dark forest green which can vary depending on how much Dioxazine Purple or Burnt Sienna you mix in. To change the value, add whatever amount of white you need. Load the tip of a no. 6 or no. 10 bristle, depending on the size of the tree and the clumps of leaves you want. Begin dabbing straight on the canvas at the center of the tree and gradually work your way outward to shape it as you desire. Remember to create interesting pockets of negative space around and through the tree.

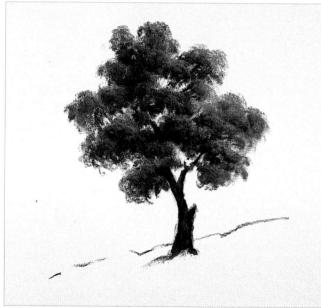

Highlight Leaves: Phase 1

It's time to decide on a light source. I chose to have the light come from the upper-right side. Take your original dark mixture from step 3 and add a little bit of Thalo Yellow-Green, a little white and maybe a little Cadmium Orange or Cadmium Yellow Light, depending on the color and value you need. In this case, the highlight should be about two or three shades lighter than the original mixture.

Load the end of a no. 6 bristle and carefully dab the highlight on the upper-right side of each clump. Use a light touch to create a light, leafy texture.

🛫 Highlight Leaves: Phase 2

Lighten the mixture you used in step 4 by adding more Thalo Yellow-Green, Cadmium Yellow Light and white. Load a no. 4 or no. 6 bristle and repeat the highlighting process from step 4 to create the next value of light. How much light you choose to use is up to you, but be careful not to overhighlight, or your clumps will become a solid mass. The next step will be the final highlight.

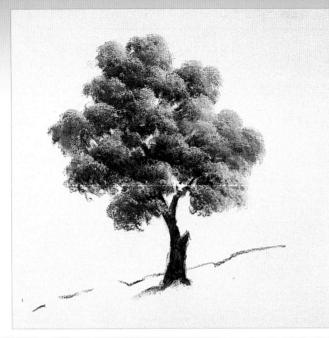

Highlight Leaves: Phase 3

Part Spinster Market Mark

6 You have several choices in this step: You can mix one part Thalo Yellow-Green + one part white, or one part Cadmium Yellow Light + one part white, or any number of very light colors, as long as they are significantly lighter than the previous highlight. Load the tip of a no. 4 bristle and very lightly dab the outer edges of the clumps. Once again, be careful not to overhighlight.

7 Add Tree Limbs

Add plenty of water to pure Burnt Umber to make a very thin, inklike mixture. Roll a no. 4 script liner in the mixture until a nice point is formed. Paint in all the tree limbs within the structure of the tree. Keep an eye on the negative space as you add the limbs so the leaves look connected to the tree.

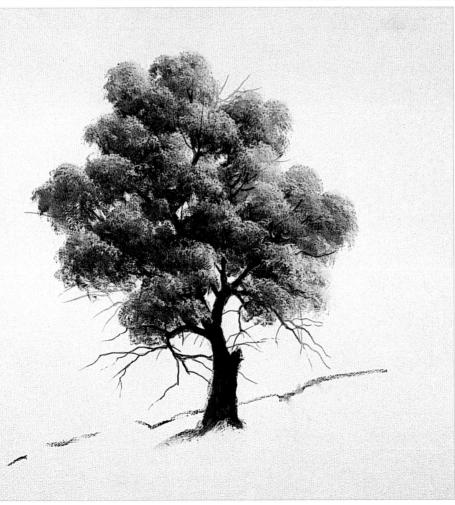

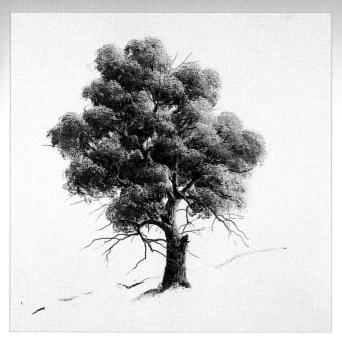

> Highlight Tree Trunk

Mix one part white with about one-eighth part Cadmium Orange, and add water to make the mixture very creamy. Load a no. 4 round sable, and, using short, choppy, vertical strokes, highlight the right side of the tree trunk and any major limbs. When this highlight dries, it may lose some of its brightness, so don't be afraid to repeat this process once or twice to achieve the brightness you're after.

🔿 Paint Grass Under Tree

Because this is a study, you need only to scrub in some grass at the base of the tree. Take some Thalo Yellow-Green with a little Hooker's Green and maybe a little Cadmium Orange. Paint this on by mottling it in a fairly thick layer using a no. 6 bristle. While the paint is still wet, put your brush flat against the canvas and push the color upward, creating a soft, grassy texture.

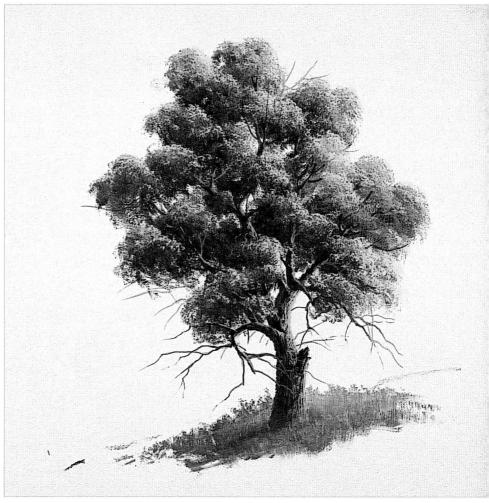

Add Final Details and Highlights

A little artistic license is in store here: You can add a few flowers of any color. Load a no. 4 bristle and dab on a few clean, bright, delicate flowers. Create an inky mixture of some dark and light colors, and paint in a few taller weeds with a no. 4 script liner.

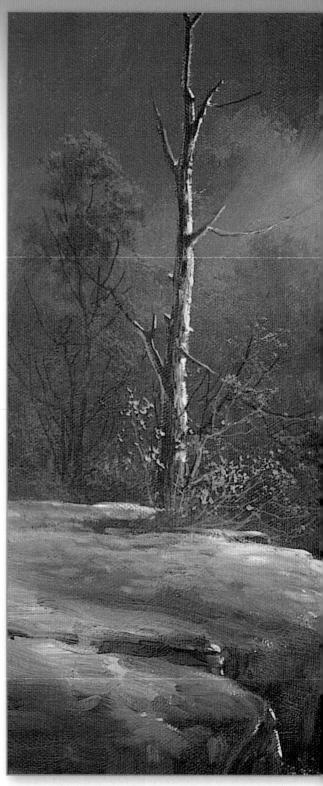

Autumn Wonders 12" × 16" (30cm × 41cm)

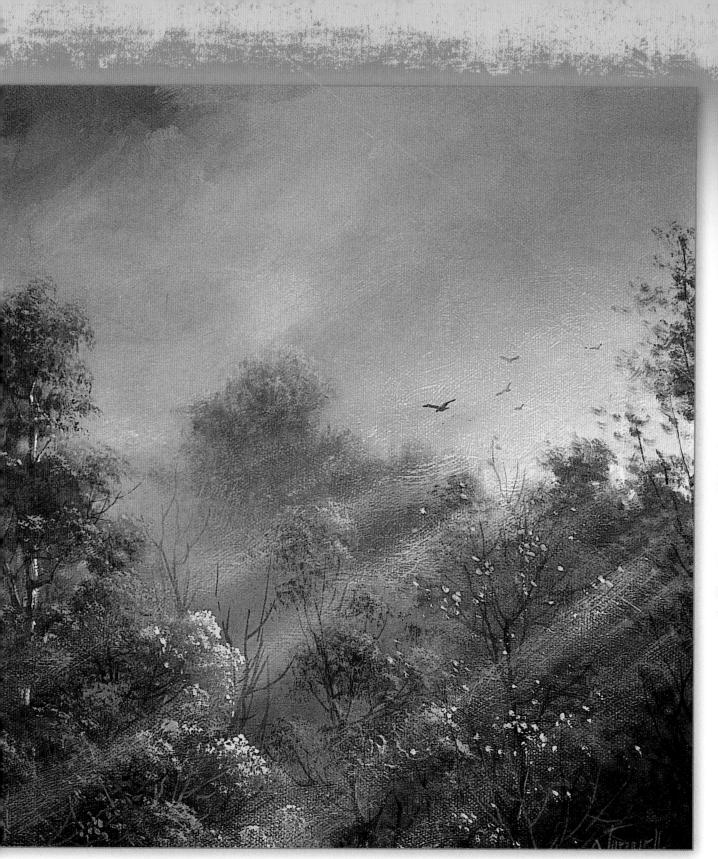

Apply the Lesson

This study shows you a technique for creating leafy trees in summer with spring, greenish tones. I thought you might enjoy seeing a collection of trees instead of one lone tree. *Autumn Wonders* was inspired by a spot near my studio in the Osage hills, which features a large variety of trees and shows autumn colors you can paint with this same technique.

THUMBNAIL STUDY

Dead Trees

I'm happy to show you how fun it can be to paint dead trees. Dead trees are wonderful assets to any landscape painting, and they are a great compositional tool—wonderful for creating pockets of negative space and breaking up negative space. They also add great character and interest to a landscape. You can make textured bark or smooth bark on dead trees. Plus, there are many varieties and shapes that will give you a wide array of opportunities to really improve your painting. This study focuses on dead pine trees.

Create Basic Sketch

Use a no. 2 soft vine charcoal to make a rough sketch of the tree's basic shape. (Note: It is best to make the sketch of the tree a little bit smaller than the actual finished tree will be. The tree tends to expand as you apply the paint.)

) Underpaint Trees

Pick up Ultramarine Blue, Burnt Sienna and a little Dioxazine Purple on a no. 4 bristle. Mottle these colors on the tree using short, choppy, vertical strokes. If you like texture, don't be afraid to apply the paint fairly thickly. However, be careful not to overblend, or it will all turn into one color.

Switch to a no. 4 round sable and paint in the stumpy branches. You will add the longer branches in a later step.

3 Highlight Trees

Highlighting the tree gives it the suggestion of tree bark and sunlight. Mix white with a touch of Cadmium Orange and a slight touch of Burnt Sienna. Add water to make the mixture creamy. Load a no. 4 round sable and begin highlighting by using short, choppy, vertical strokes. Go up and down the right side of the tree, leaving small pockets of negative space to help suggest the texture of bark. Gradually work your way across the tree until the highlight fades into the dark side. If the highlight dries too dull, you can go over it one or two more times until you are happy with the brightness.

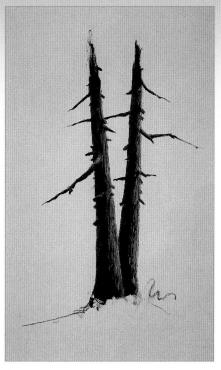

Add Reflected Highlight I have discussed the use of reflected highlights before in some of my other books and other studies. In this step, we use a soft, cool, reflected highlight. This highlight will be on the shadowed side of the trees to help create a rounded appearance. This reflected highlight is especially effective on large tree trunks that have a darker, shadowed side.

Create a mixture of one part white + one-fourth part Ultramarine Blue + a touch of Dioxazine Purple. It should be a fairly deep medium, bluish purple; be careful it's not too white. With a no. 4 round sable, apply this color on the very edge of the shadowed side and then gradually work it over to the center of the tree. Be very careful not to make this highlight too solid. Leave little pockets of negative space, just like you did when applying the warm highlight on the right side.

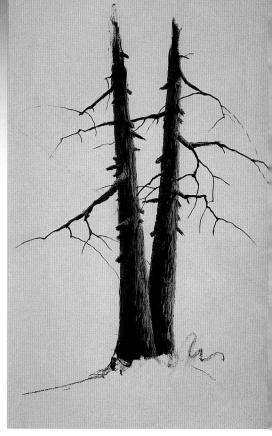

🛫 Add Final Tree Limbs

Wix equal parts Ultramarine Blue and Burnt Sienna, and add water to create a very thin, inklike mixture. Roll a no. 4 script in the mixture until a nice point is formed. Continue finishing out the limbs you began in step 2. Remember to make interesting shapes, allowing some of the limbs to overlap each other, which will create interesting pockets of negative space.

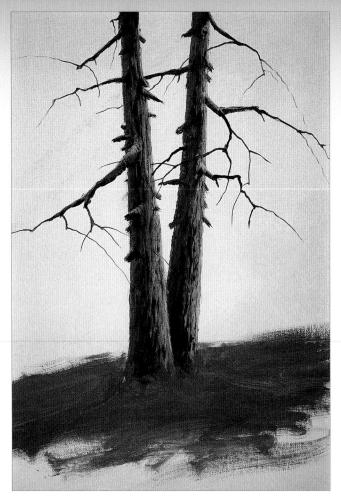

🛫 Underpaint Snow at Base of Tree

Though this study is mostly about the trees, it's important to know how to place the trees on the ground. Mix Ultramarine Blue + a touch of Burnt Sienna + a touch of Dioxazine Purple and just enough white to create a medium-value, purple bluish color. With a no. 4 bristle, scrub this shadow color all along the base and behind the tree. Drift this color up against the side of the tree to make it appear as if the trunk is settled in the snow.

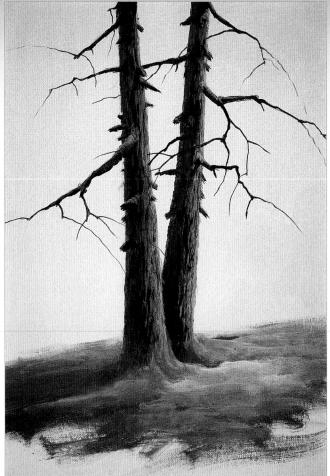

r Highlight Snow: Phase 1

Profile Startes

Add a very slight touch of Cadmium Orange to pure white to create a tint rather than an actual color. Thin the mixture with water until it is very creamy. Load a small amount on the end of a no. 4 bristle and begin scrubbing on the highlight, creating little mounds of drifted snow. It's especially important to drift this up against the right side of the tree base. If you happen to overhighlight and lose the pockets of negative space, take the gray underpainting color from step 6 and paint out that area to start over.

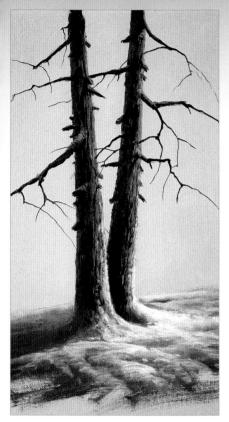

📿 Highlight Snow: Phase 2

This is a very simple step, basically called spot highlighting. Load the tint from step 7 on a no. 4 flat sable fairly heavily. Pick selected spots you want to give a much brighter highlight and rehighlight these areas using much thicker paint. The brightness of the snow is up to you. Have fun, but be careful not to overdo it.

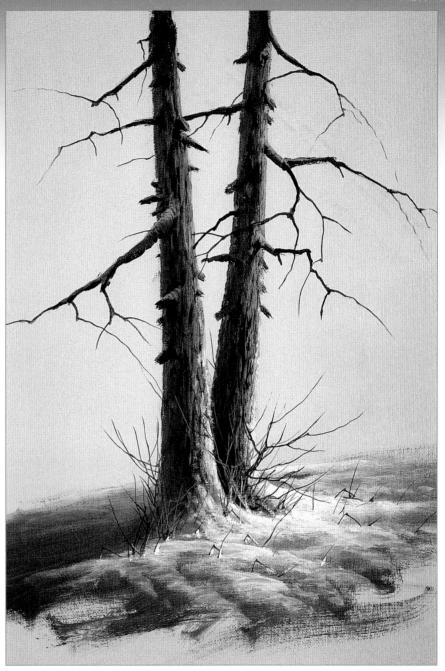

🕥 Add Grass, Weeds and Final Highlights

This step is quick. Mix Burnt Sienna with a little bit of Ultramarine Blue to create a dark brown. Use water to thin the color to a very thin inklike consistency. Roll a no. 4 script liner in this mixture until the brush forms a sharp point. Paint in the weeds and dead bushes. Don't hesitate to add more limbs on the main tree. After you finish, add some very clean, bright highlights at the base of the weeds and bushes, using the highlight color from step 8 and a no. 4 round sable. This will add a little sparkle to the snow.

THUMBNAIL STUDY

Snow-Covered pine Trees

The most common misconception about painting snow, whether it lies on trees, on the ground or on any other object, is that snow is white. This could not be further from the truth. Snow takes on many different colors and values of colors, as you will see in this study of the snow-covered pine trees. This technique is the same technique you will use when putting snow on other objects as well.

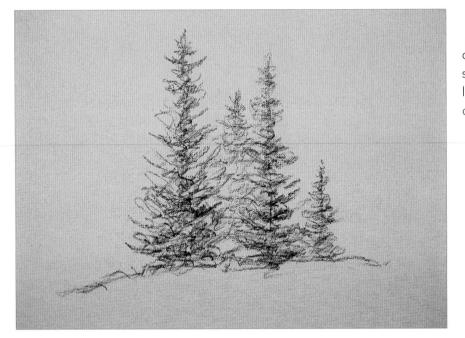

Create Basic Sketch

First, use soft vine charcoal to draw a rough, simple compositional sketch of the tree grouping. Sketch lightly and remove the excess charcoal dust by blowing on the canvas.

Mix Color

You can mix the basic pine-tree colors with either a palette knife or brush. The mixture is made of one part Hooker's Green + one-fourth part Dioxazine Purple + one-fourth part white (gesso). This is only the base color.

If you want to make the color warmer, add a little Cadmium Red Light or Burnt Sienna. If you want to make it cooler, add Ultramarine Blue. If you want it to be grayer, add a little more Dioxazine Purple. To change the value (lightness or darkness), add more gesso.

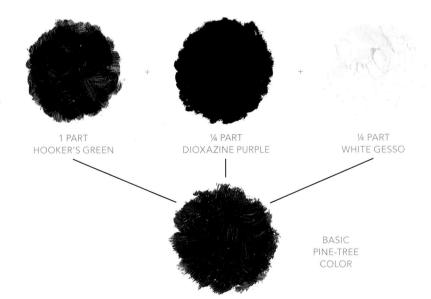

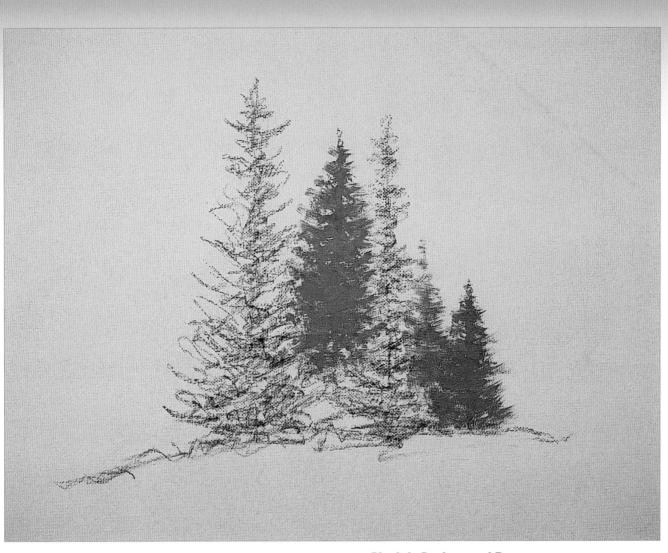

📿 Block in Background Trees

Moderately load a no. 4 bristle with a light value of the green pine-tree mixture about two shades darker than the background. Block in the background trees but don't load the brush too heavily. Dab straight on the canvas, forming the basic shape of each background tree.

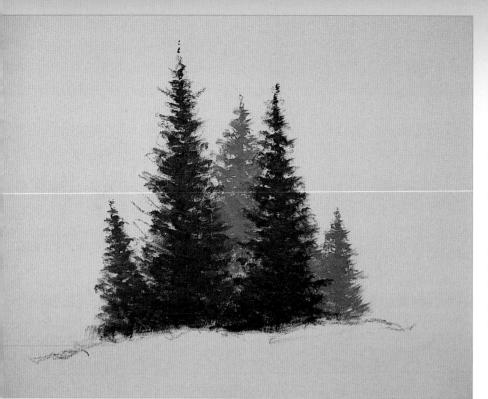

lighten the value. This should give you a medium-value

Block in Front Trees

Start Martin

Switch to your no. 6 bristle and load the brush a little heavier. Begin blocking in the front trees by dabbing in the darker foreground color you have chosen. Start blocking in the tree from the center. Work your way up a little at a time and then work your way down a little at a time to gradually form the basic shape of each tree.

Notice that each tree has a slightly different shape and height. Also note that each tree overlaps the others. Apply the paint thick enough so the background does not show through. You may need to double coat the trees to ensure the paint coverage is opaque.

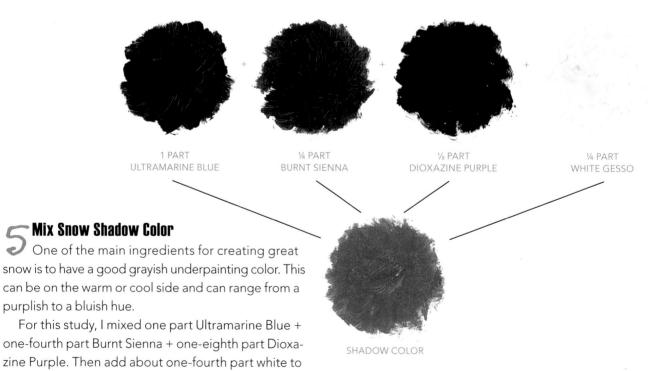

purplish gray.

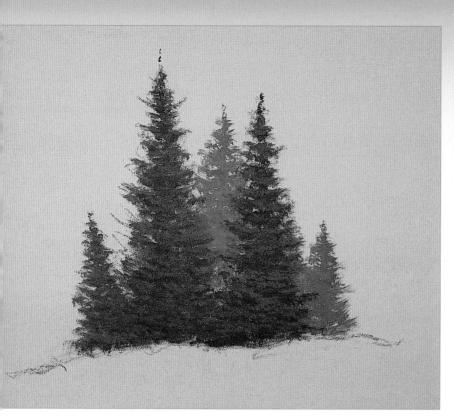

Landscape Secret

It's very easy to overuse the shadow color. If you put too much in any particular area, you can easily fix it by rebuilding that particular section of tree with the dark green tree color from step 2. Then, start the process again.

Block in Snow Shadows

Load the tip of your no. 4 bristle with a small amount of the shadow color from step 5. Carefully dab this color on the foreground pine trees. Distribute the color in irregular patterns throughout each tree. It's very important to leave some of the dark green underpainting color showing through this shadow color.

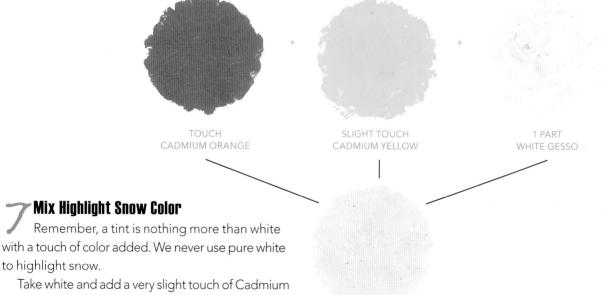

Take white and add a very slight touch of Cadmium Orange and a slight touch of Cadmium Yellow Light. This will create a very nice, soft tint.

HIGHLIGHT TINT

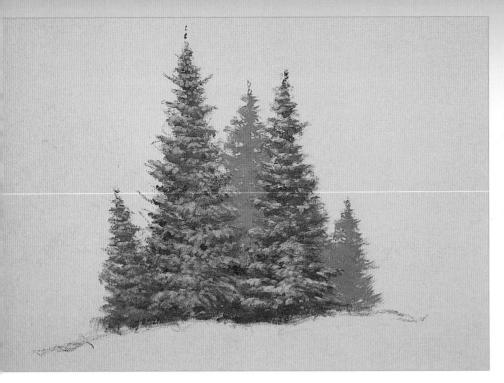

B Highlight Pine Trees: Phase 1 Take a bit of the highlight tint from step 7 and add a little bit of the snow shadow color. Thin this mixture

with some water and load a little on the tip of a no. 4 bristle. Carefully dab this color on the shadow area of the snow, creating the first value change.

Don't cover up the entire shadow color; this is only phase 1. There are two other phases to complete, and highlights are brightening in a gradual process. It's very important not to overhighlight at this stage.

Highlight Pine Trees: Phase 2 This step repeats step 8, but this time you will use the highlight mixture in its pure form. Load the tip of a no. 4 bristle with a small amount of the highlight tint from step 7. Do not thin the mixture; the highlights need to be very opaque. Carefully dab this highlight color on the trees. It's OK if the paint goes on with a little texture. Again, be very sure you do not overhighlight or cover up all the underpainting color.

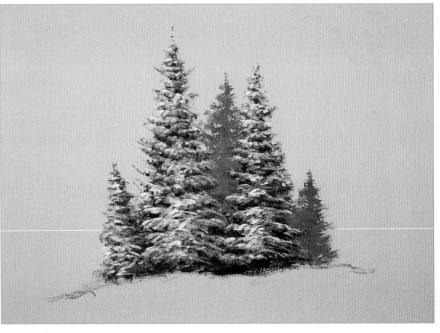

🕤 Highlight Pine Trees: Phase 3

In this step you will accent highlight, which means you will highlight only specific areas of the trees. Load a no. 4 flat sable fairly heavily with the highlight color from step 7. Look for areas where thicker, brighter snow will give the tree more light and form. This is a good

time to stand back and look at the study from a distance. Then add this highlight to the areas that you think might make your tree study have better form and light.

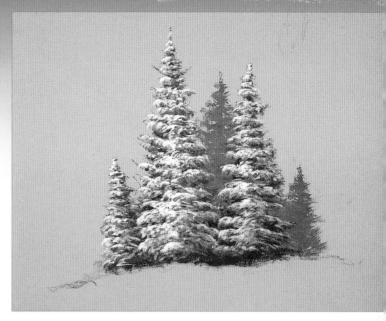

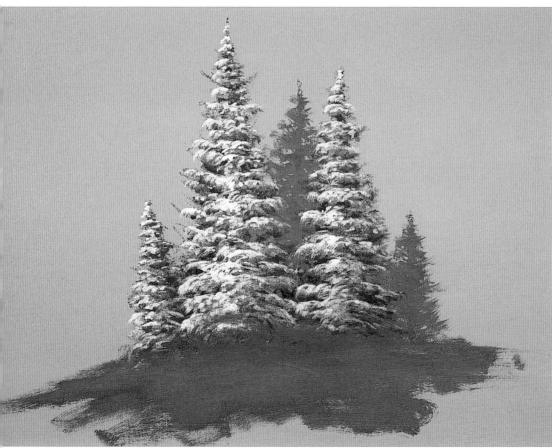

Underpaint Foreground Snow

The next two steps help settle the trees into the ground so they will have a base. Load a no. 6 bristle with the original snow shadow color you mixed in step 5. Scrub this color along the base and up into the lower boughs of the trees, making sure you leave very soft edges.

Highlight Foreground Snow

Load a no. 4 bristle with a little of the original snow highlight color mixed in step 7. You want the snow to look as if it has drifted and piled at the base of the trees, so leave pockets of negative space here and there, creating good compositional eye flow.

Landscape Secret

terioris state and the

When highlighting snow, don't overload your brush, and be sure the paint mixture is the consistency of soft butter. It's better to gradually increase the intensity of the highlight than to put it on too heavily. You can brighten the highlight in the last step.

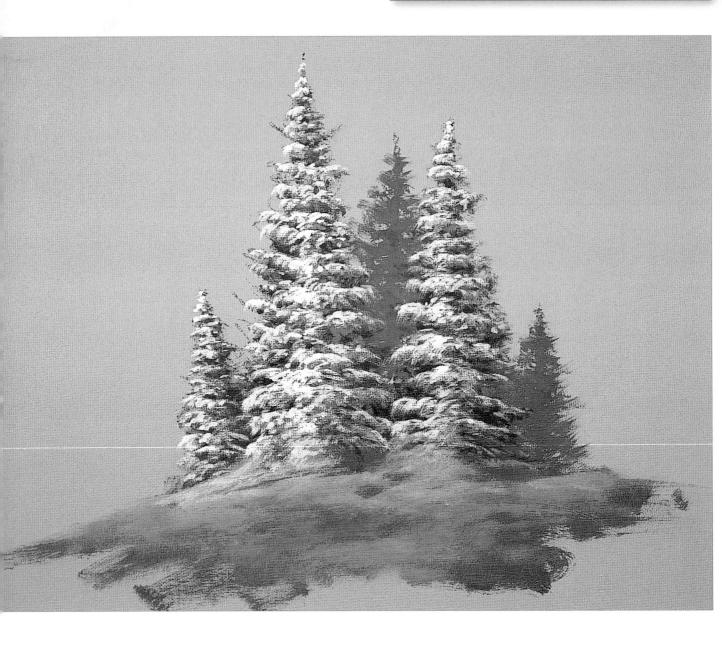

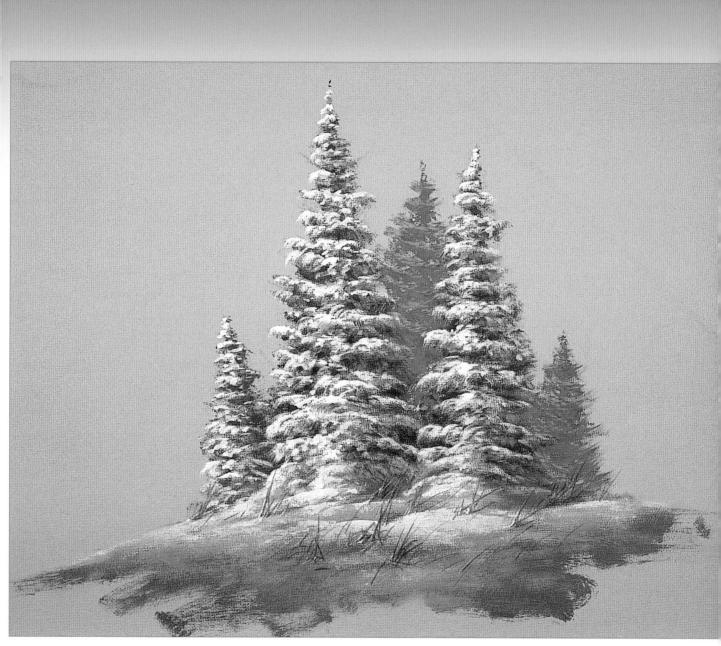

Add Miscellaneous Details: Highlights, Shadows, etc. You may not actually need to do much in this step. If you're happy with the brightness of the snow, leave it alone. Otherwise, load a no. 4 bristle with the snow highlight mixture from step 7 and go over the existing highlighted areas until you're pleased with the brightness.

Add a few weeds with a no. 4 script liner. You also may want to soften the background trees by drybrushing a little of the snow shadow color over those trees to set them back a bit.

THUMBNAIL STUDY Falling Snow

You may not be a "snow person," but the process of creating falling snow is one of the more fun things you will paint. The process is very simple and effective. It is simply a matter of creating a very thin wash and then taking your toothbrush and spattering some snowflakes. Falling snow adds a little drama, or a peaceful effect, to a snow scene, depending upon how you look at it. This study takes only three steps, so it's a quick and easy thing to learn.

Paint Background

Begin with a grayish, mottled background. Create a mixture of one part Ultramarine Blue + one-fourth part Burnt Sienna + about one-fourth part white + a touch of Dioxazine Purple. Make this mixture nice and creamy. Load your hake brush and paint the background using large "X" strokes. If the background is too dark, add a little white as you go, or you can even add some of the other colors if you need to change the hue. The important thing is that the background is not too light.

Paint Wash and Flick Snow

Before you start this step, be sure the background color is completely dry. Premix the snow color, which is nothing more than white with enough water to make it fairly soupy. Let that mixture set for a second and then load a hake brush and put a thin wash of water and a slight touch of white all across the background.

While the wash is still wet, load a toothbrush with the snow color and run your forefinger across the bristles, spattering the snowflakes on the wet background. Notice that they begin to bleed a little bit, which is OK. The bleed creates the softer, more distant snowflakes. You will probably need to experiment with this technique to get the hang of it. The final results depend on how close you hold the brush to the canvas when you spatter and how soupy your snow mixture is. This determines how large or small the snowflakes will be.

🐊 Spatter Final Snowflakes

These final snowflakes will be the close-up, more distinct snowflakes. The canvas should be completely dry, which will keep these new flakes clean and bright. Create a soupy mix of water and white paint. Load the toothbrush and spatter the canvas, holding the brush close to the canvas.

FULL PAINTING DEMONSTRATION

Snow Country

Snow is one of the most interesting, challenging and difficult subjects to paint, whether or not you like to paint it. Learning the process for painting snow will help you in many other areas of your painting career. Even if snow makes you cold, I suggest you give it a try. You will be surprised how learning the steps involved will truly inspire you and increase your artistic horizons.

The greatest misconception about painting snow is that snow is white. I have the privilege of critiquing student paintings from around the world. The most common problem with their snow scenes is that most students use pure white for the snow. As I explained in the Snow-Covered Pine Trees study (page 94), the reality, at least in the art world, is that snow is not white but a tinted white. Snow and anything else white typically begins with a deeper underpainting color of some form of gray. You can use either a warm or a cool gray that has some color mixed in, such as a greenish gray, bluish gray, reddish gray, purplish gray, brownish gray, etc. For this painting, I'm going to use a warm gray that's on the red side.

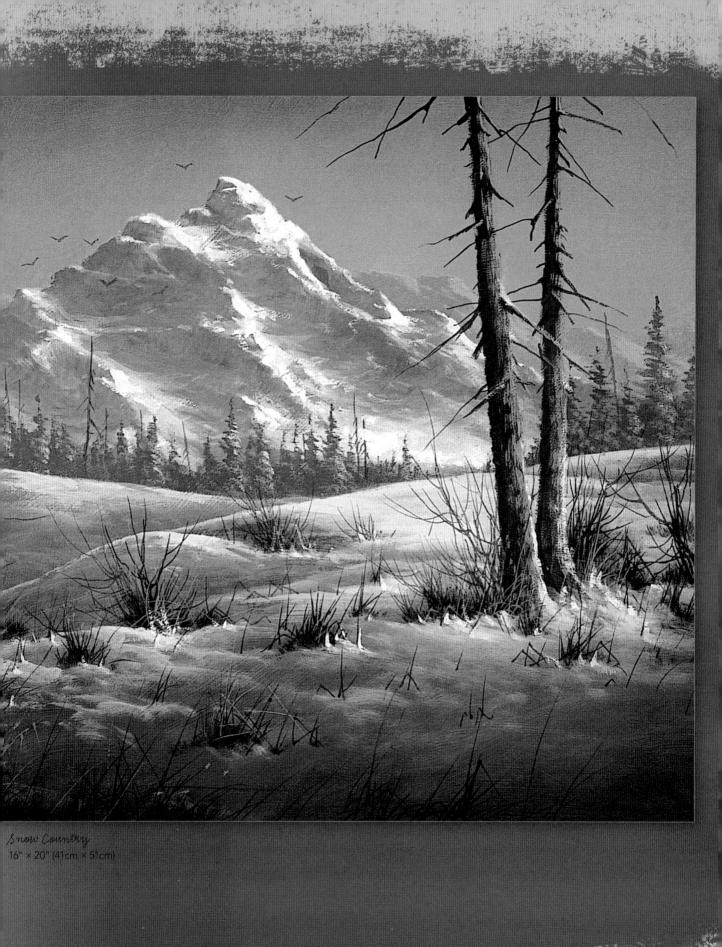

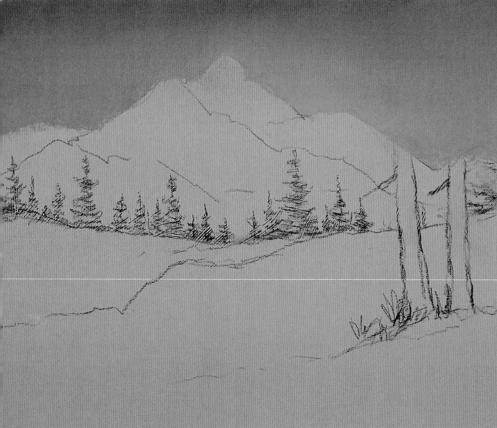

Create Basic Sketch

Mix Ultramarine Blue + about one-fourth Burnt Sienna and then add about half as much white to this dark mixture. Play with this mixture until you get a medium gray. Then coat the canvas with your hake brush. Let this dry.

Begin with a simple, rough sketch using your soft vine charcoal. Keep the sketch loose; you will make several adjustments with the sketch as the painting progresses.

Block in Sky With a palette knife, mix white with a little Cadmium Orange and a little Cadmium Red Light to create a soft, warm horizon color. Add a little water to the mixture to make it very creamy and then paint the entire sky with a hake brush.

While the sky is still wet, pick up a little Ultramarine Blue and a little Dioxazine Purple on the hake brush and, starting at the top of the sky, blend across and down using large "X" strokes. The process should create a nice, gradually blended sky. It's OK if you see variations of light and dark areas.

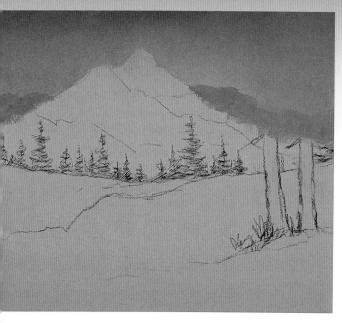

2 Underpaint Background Mountains

Mix a soft, grayish purple for the first range of distant mountains. Start with white and then mix a little Ultramarine Blue + a touch of Dioxazine Purple + a touch of Burnt Sienna, making it turn gray. You want this to be a little on the purple side and just slightly darker than the sky (horizon). You will need to play with the mixture until you get the right color and value. Load your no. 4 or no. 6 bristle and block in the background mountains using broad, loose, impressionistic strokes.

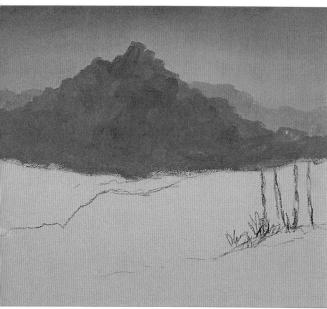

1 Underpaint Midground Mountains

These are the larger, more dominant mountains. They are painted the same as the background mountains in step 3, but they are about two values darker. Darken the mountain mixture from step 3 by adding more Ultramarine Blue, Burnt Sienna and a bit more Dioxazine Purple.

Load this color on a no. 10 bristle fairly heavily. Apply the paint to the mountains heavy enough to ensure the canvas is well covered. It's OK if you have brushstrokes showing, and even a little texture is fine as long as all the canvas is covered. Don't leave any hard edges along the outer shape of the mountains.

5 Highlight Background Mountains Mix white + a touch of Cadmium Orange. Add a small touch of the purplish gray mixture, used for the mountains, to slightly gray the mixture.

Load a no. 4 bristle and highlight the background mountains by drybrushing on this highlight. The light source is coming from the right side, so your brushstrokes should be focused on the upper-right side of the mountain peaks.

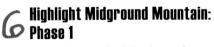

This step helps you find the basic formation of the mountains' inner structures. Add water to the highlight mixture from step 5. Load a small amount on a no. 4 bristle and begin scrubbing in the basic contour of the inner parts of the mountains. Please remember you are only locating the basic formations. Major details or highlights will be added later.

You will have to experiment with the compositional arrangement of your brushstrokes. If you're not happy with them, start over by painting out the area you don't like with the gray underpainting color.

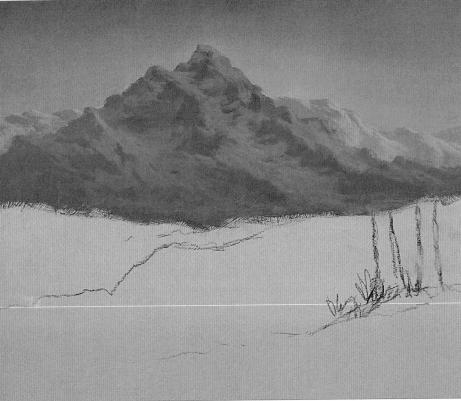

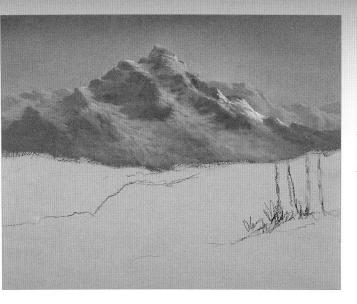

ア Highlight Midground Mountain: Phase 2

This is the first phase of snow. Create a slight tint by adding a very small touch of Cadmium Orange to a little white. Load this mixture on a no. 4 bristle and begin laying in the snow-covered areas of the mountain. Keep in mind you have a couple of other layers of snow to finish the highlighting process. All you're doing here is locating the main masses of the snow areas. Therefore, it's not necessary to apply the snow too heavily.

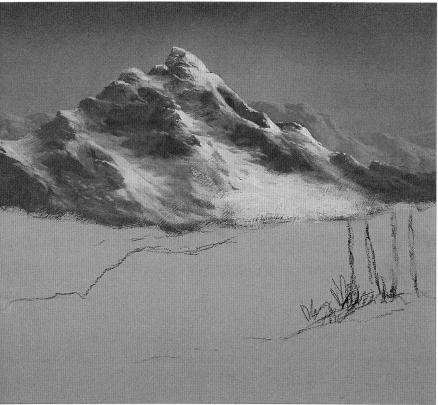

🔿 Highlight Mountains: Phase 3

O By now you are probably beginning to notice that this painting technique builds layer upon layer. This phase adds the brighter areas to the snow masses created in step 7.

Load a no. 4 bristle fairly heavily with the highlight mixture from step 7. Go over the areas you just established in step 7. Apply the paint much thicker; at this point, you can make minor adjustments in the shape of the basic snow masses. Don't be afraid to experiment and change things around.

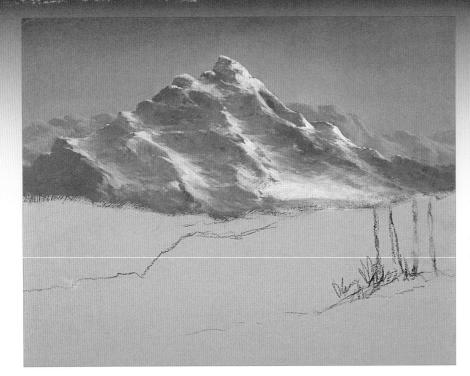

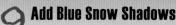

The secret to making snow look really cold is to add a bluish purple shadow on the back side of the highlighted snow areas.

Mix blue + a touch of Dioxazine Purple + enough white to create a medium value. If you choose to make this more gray, add a little Burnt Sienna to the mixture. Take your no. 4 bristle and scrub in a soft shadow on the back side of all the main snow masses.

Block in Distant Pine Trees The midground pine trees are one part Hooker's Green + about one-half Dioxazine Purple + a touch of Burnt Sienna. Of course, you will want to add a little white to change the value; this value should be about two shades darker than the mountain. As you can see, these are distant trees; therefore, they don't need to be very detailed but rather semiimpressionistic and very suggestive. Leave interesting pockets of negative space to create good eye flow. Take your no. 4 bristle and block in these trees loosely and quickly. Don't make them too detailed, but still have fun with this process!

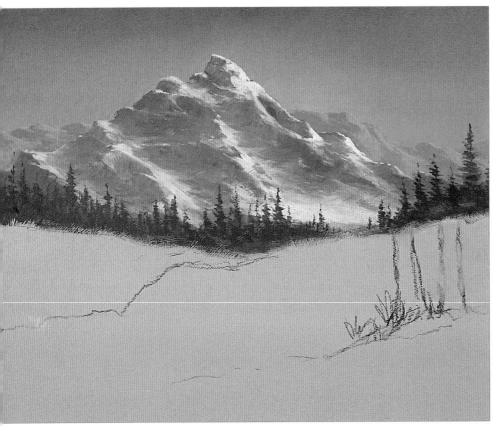

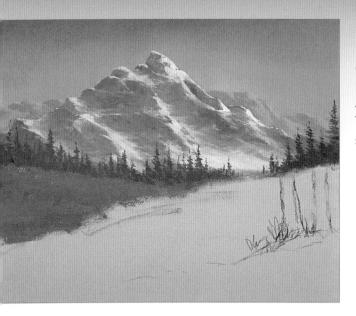

/ Underpaint Background Snow

For this small area of the midground, you need a middle-tone, mauvish gray made of Ultramarine Blue + a touch of Burnt Sienna + a touch of Dioxazine Purple. Add just enough white to create a middle-tone value. Take your no. 6 bristle and underpaint this area, making sure the canvas is well covered.

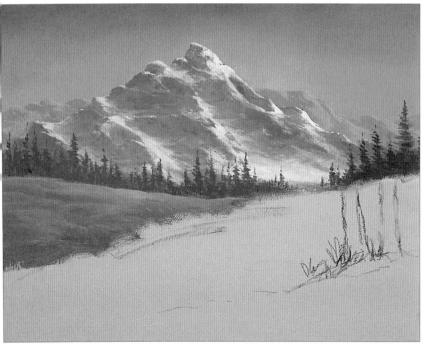

Highlight Background Snow Step, so don't piddle, play or putter. Mix a highlight color of white + a touch of orange to create a tinted white. Thin this tint to almost the consistency of melted butter. Load a small amount on a no. 4 bristle and scrub in the highlights in this area, keeping the highlights very soft. You want to create the suggestion of drifted snow. Don't get it too bright yet. You can brighten the snow in a future step if needed.

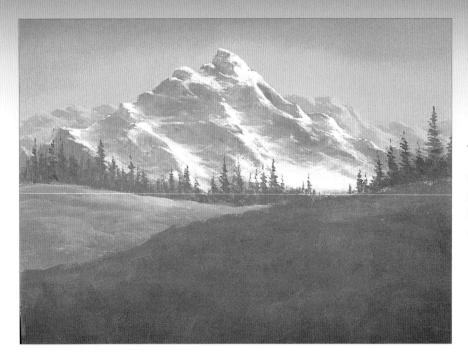

3 Underpaint Foreground Snow

This step is almost identical to step 11. Create a mixture of Ultramarine Blue + about one-eighth Burnt Sienna + a touch of Dioxazine Purple. Add just enough white to create a deep, medium gray slightly on the purple side. Load a no. 10 bristle and underpaint the entire foreground using broad, bold strokes. Make sure the entire canvas is covered.

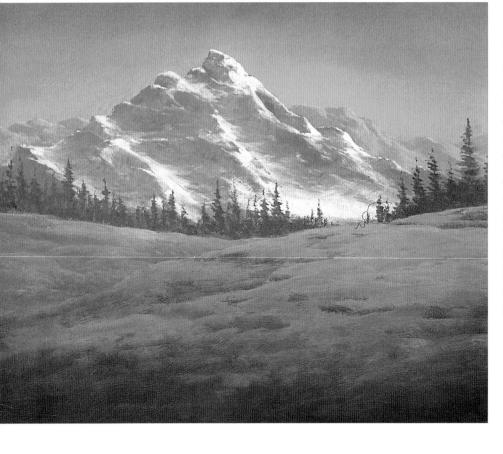

4 Highlight Foreground Snow: Phase 1

This step creates the main flow of the snowdrifts. Begin with a tinted white (white + a touch of Cadmium Orange) thinned to a very soft, creamy consistency. Load a very small amount on the end of a no. 6 bristle and scrub in the basic snowdrift formations. A word of caution: Be sure not to overload your brush. It takes very little paint to accomplish this first phase. Too much thick paint will create large masses of snow that will be hard to blend out, so take it slow and easy and be sure you create very soft, blended edges.

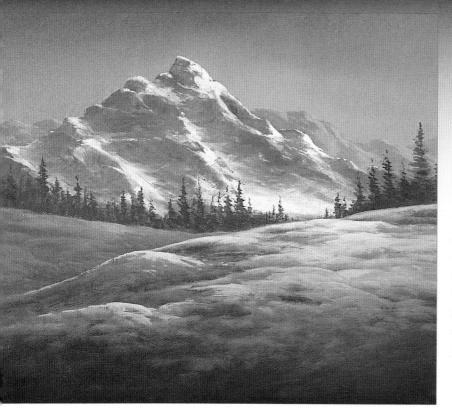

5 Highlight Foreground Snow: Phase 2

This step brightens the highlight on the snow. The key to this phase is to add a little more white to the tint from step 14, which makes the color more opaque and brighter. The brighter tint needs to be creamy, but not as thin as the mixture in step 14. Load a small amount on the end of a no. 4 bristle and begin scrubbing this color on top of the existing highlight. This should substantially brighten the areas. Let it dry and then repeat this step again if you want it brighter.

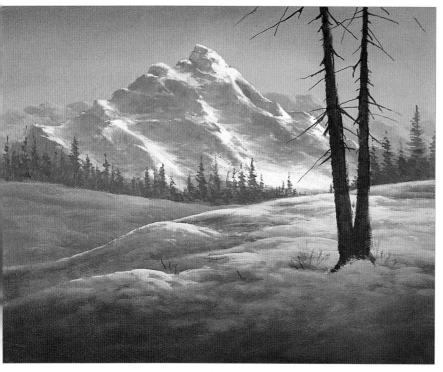

6 Underpaint Dead Pine Trees

You might want to use a soft vine charcoal to make a quick, rough sketch of the trees' basic shapes. Then double load a no. 4 bristle with Burnt Sienna and Ultramarine Blue. Use vertical, choppy strokes to block in the entire tree. Don't overblend the colors; you want only to mottle the colors on the trees so you can still see both the Ultramarine Blue and the Burnt Sienna. If you overblend, the trees become one dark color and are not quite as interesting.

Load the blue-brown mixture on a no. 4 round sable and paint in the basic tree limbs. The limbs and details will be finished in a later step.

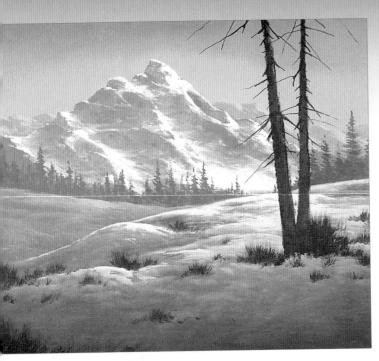

Underpaint Foreground Bushes

Mix Burnt Sienna + a touch of Dioxazine Purple + just enough white to create a nice, warm, soft middle-tone value. Add water to make the mixture very creamy.

The secret is to load a small amount of paint on the end of a no. 4 bristle and then make quick, vertical strokes upward to create the clumps of grass. The arrangement of each clump is critical to the composition and eye flow. Arrange each clump so your eye doesn't bounce around the painting.

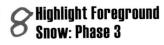

It's time to really bring the snow to life. Put a fairly heavy load of the highlight tint from step 15 on a no. 4 flat sable brush. Smudge this color using an upward comma stroke at the bases of the trees and at the bases of each of the clumps of grass. Also apply this highlight to any mounds of snow or areas you feel need to be brighter. Don't be afraid to let the color dry and then repeat the highlighting process again. It sometimes takes several applications of highlight to get things as bright as you want them.

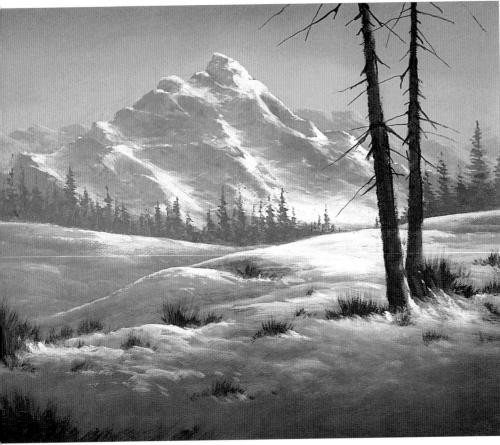

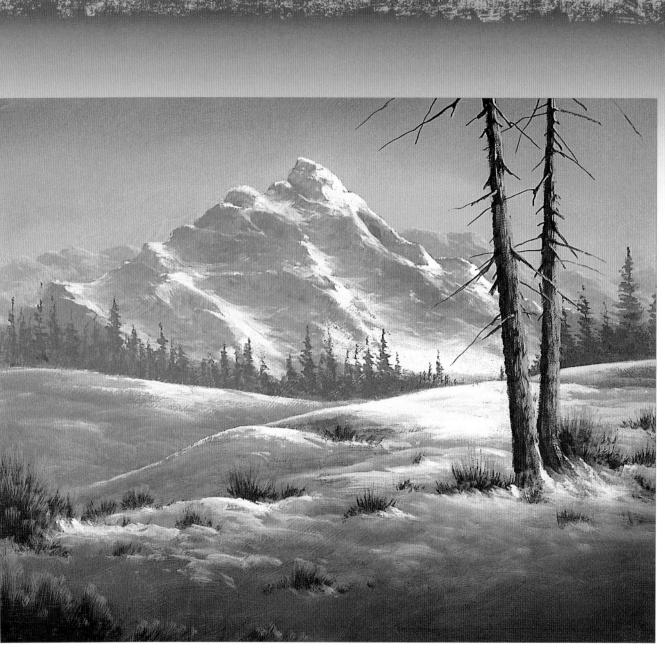

🔿 Highlight Pine Trees and Bushes

We want to create a highlight and barklike texture at the same time. Create a mixture of white + a touch of Cadmium Orange + a slight touch of Burnt Sienna. Make the mixture nice and creamy then load it fairly heavily on a no. 4 round sable. Apply this highlight color using short, choppy, vertical strokes all the way up the right side of the tree, gradually fading this over onto the left side of the tree.

After you finish the bark, use a no. 4 bristle and the same highlight color to drybrush a soft highlight on the top of each bush. I usually use a downward, vertical stroke for this application.

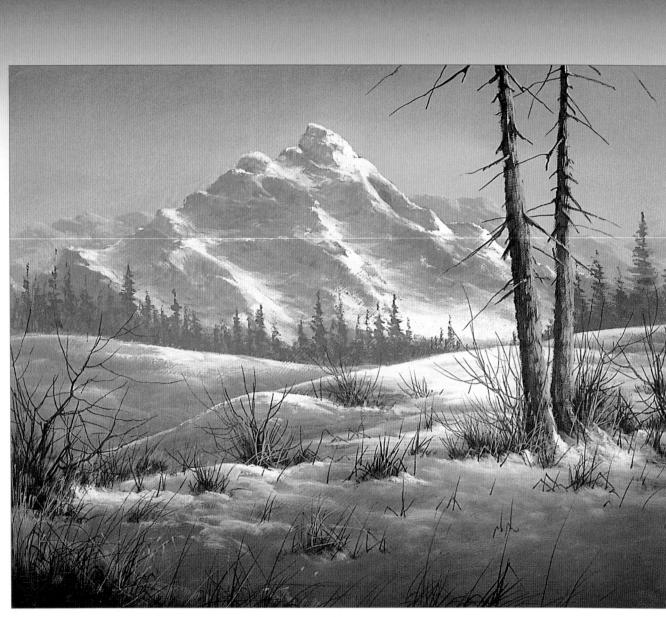

20 Add Weeds and Dead Bushes Mix Burnt Sienna + a touch of

Mix Burnt Sienna + a touch of Dioxazine Purple + a touch of Ultramarine Blue. (The mixture needs to be on the warm side.) Thin it to a very thin, inklike consistency. Take a no. 4 script liner and roll it in the mixture, forming a point on the end of the brush. Paint in all the dead bushes, twigs and weeds. Don't be afraid to put in quite a few so there is plenty of overlap and good eye flow.

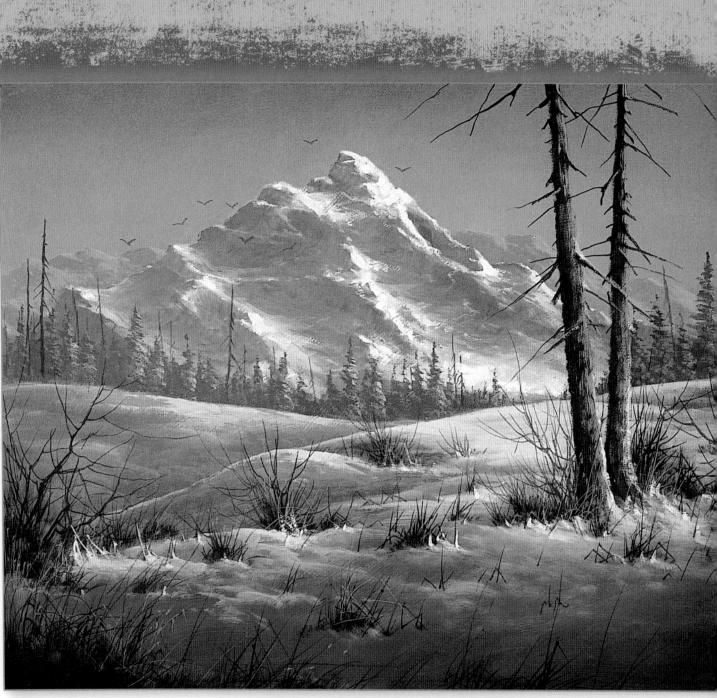

Add Miscellaneous Details and Highlights We are finally at the step where you can really put your artistic license to work. Everyone will finish up their painting differently, but you will mostly want to do things like: add brighter highlights to certain areas; add more tree limbs, weeds or dead bushes; or even add a few birds flying in the distance.

In my painting, I used my no. 4 round sable to add thick dabs of the snow highlight at the bases of the weeds and bushes. This gives the snow a little sparkle. I also highlighted the mountain peak a bit. I used a no. 4 script liner to add a few distant birds.

Study your painting and look for areas you can improve. Remember my motto: Don't piddle, play or putter. If you aren't careful, you'll probably overwork it and, as a result, be unhappy. You can always improve on the next painting.

High-Country Waterfall

If you've been studying my books or following my television show for very long, you already know I love to paint mountains and waterfalls—especially when they're combined. This waterfall scene is similar to another waterfall I did in my first book, *Painting Basics*. However, I chose to do this type of scene again because it fits so well with all the studies you have learned in this book: rocks, trees, grass, clouds, etc.

Plus, this particular painting is a little more advanced and will have more comprehensive explanations accompanying it. It will be a fairly challenging painting, but the learning experience will be well worth all the effort you'll put into it. Grab your brushes and some courage and let's get started!

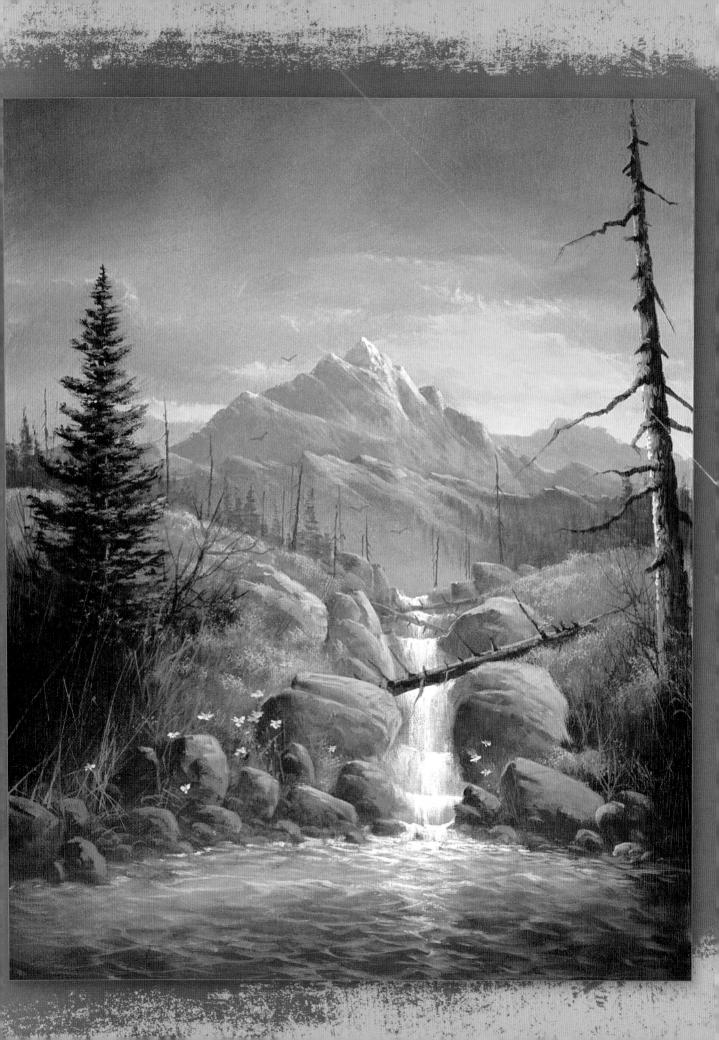

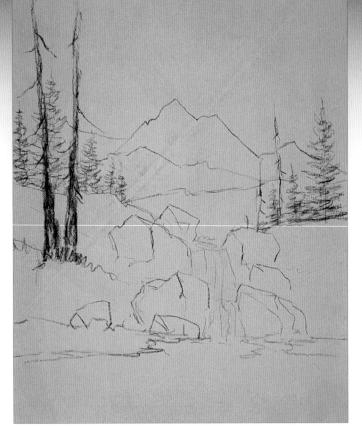

Create Basic Sketch

Normally I suggest that your sketch doesn't need to be too accurate, but, because the composition is more complicated in this painting, it's probably a good idea to spend a little more time making sure you're very satisfied with the arrangement of objects. If you're pleased with your sketch, you won't need to alter things too much when you get further along in the painting. As always, use a no. 2 soft vine charcoal for the sketch.

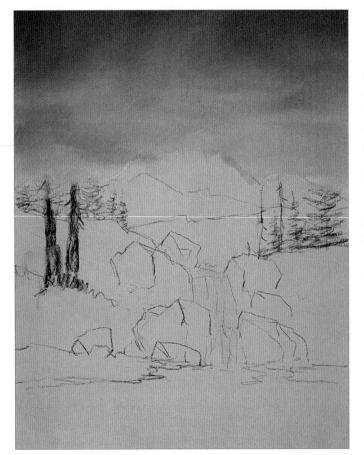

) Block in Sky

You will create two color mixtures. The first is a nice, soft, golden hue for the horizon: Mix one part white + about one-eighth part Cadmium Yellow Light + about one-eighth part Cadmium Orange. Create the darker mixture of one part Ultramarine Blue + oneeighth part Burnt Sienna + one-eighth part Dioxazine Purple + about one-fourth to one-half part white, depending on the value you desire. Make both mixtures very creamy.

Load a hake brush with the horizon color and paint large "X" strokes all the way to the top of the canvas. While this color is still wet, start using your darker mixture at the top and begin blending downward, creating irregular pockets of negative space to suggest semistormy clouds.

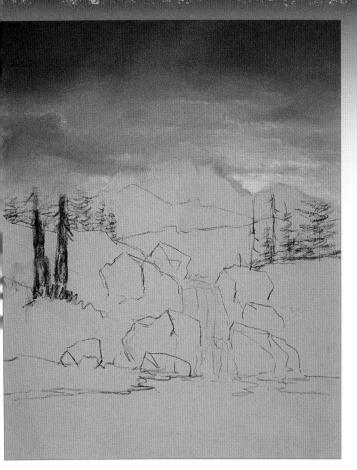

2 Finish Sky

Make sure the sky is quite dry before you start this step, which gives the sky a much brighter glow. Load a no. 4 flat sable with the horizon color. Starting at the area just behind the mountain, apply the color and carefully blend it along the base of the sky. You want the sky to be a little brighter on the right side, just behind the large mountain. You can make this sky as bright as you want, so don't be afraid to repeat one or two more times. Take your no. 4 round sable and paint a silver lining along the edges of some of the darker clouds using the horizon color.

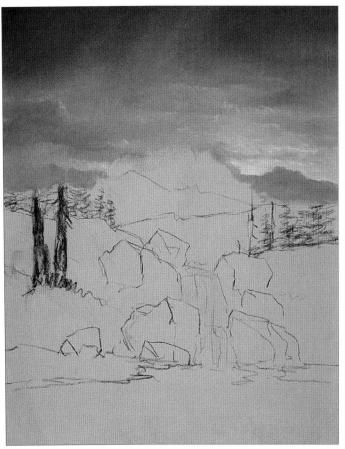

🕂 Block in Background Mountain

Use a no. 4 flat bristle to paint in the mountain farthest away. You can use the dark mixture from step 2 if it's the correct value (it needs to be about two to three shades darker than the sky). However, if the mixture is too dark, add a little white to change the value.

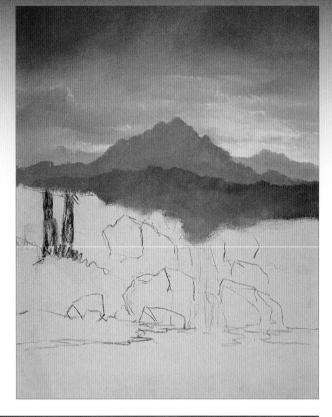

S Block in Midground Mountains

Darken the mixture you used in step 4 by about two values by adding a little more Dioxazine Purple, a little more Ultramarine Blue and a little more Burnt Sienna. Load a no. 4 bristle and paint in the midground mountain. Make sure the mountain has a very interesting shape. Take the same mixture and darken it a little more. Using the same brush, block in the very foreground mountain.

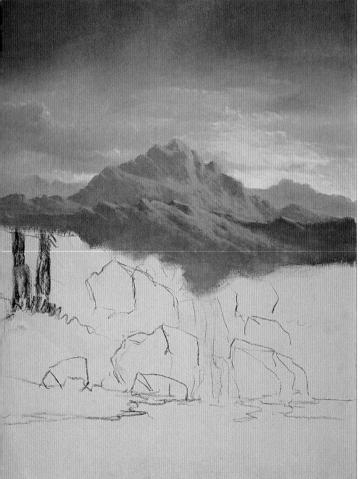

🖉 Highlight Mountains: Phase 1

6 Create a highlight color of white + a touch of Cadmium Orange. Thin the mixture so it's very creamy. This is only phase 1 of establishing the basic structure of the mountains, so don't highlight too brightly yet. Allow more moisture on your brush and use less paint to assure the highlights are not too bright.

Load a small amount on your no. 4 bristle or no. 4 flat sable (you may want to test to see which one works best for you). Paint the highlights, creating very interesting pockets of negative space, giving the mountains the appearance of being three-dimensional.

Paint the very front mountain the same way, but add a little more Cadmium Orange to the mixture.

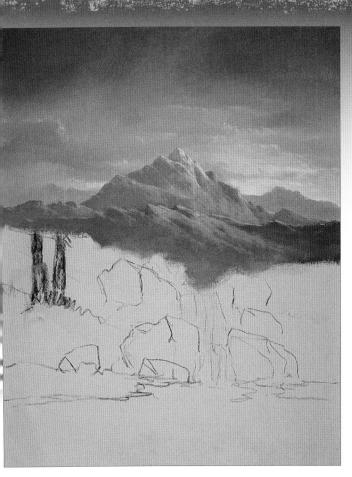

🍸 Highlight Mountains: Phase 2

Be sure you are pleased with the way you shaped your mountains in step 6 before you begin the second phase of highlights. Take the same mixture you created for the foreground mountain highlights and increase its intensity by adding a bit more white and a bit more Cadmium Orange. Apply the highlight a little more opaquely so the result will be brighter. Load a no. 4 flat sable and rehighlight the areas you already highlighted in step 6. Do not cover up any of the negative space you've already created.

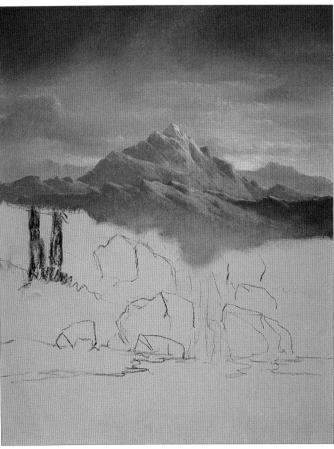

📿 Apply Mist at Base of Mountains

Create a mixture of white + a touch of Ultramarine Blue + a touch of Dioxazine Purple. This should be a nice, soft, bluish purple color definitely on the blue side. Load a small amount on a no. 4 bristle and begin scrubbing in this color, using a very tight, circular motion. Scrub your way up and then scrub your way down, creating a soft mist.

🔿 Paint Distant Pine Trees

Create a mixture of one part Hooker's Green + about one-fourth part Dioxazine Purple + about one-fourth part white. This value needs to be about three values darker than the value used on the mountains. Use either a no. 4 flat sable or no. 4 bristle to paint in the distant pine trees. Be careful not to make them too detailed; they should be only suggestive in form.

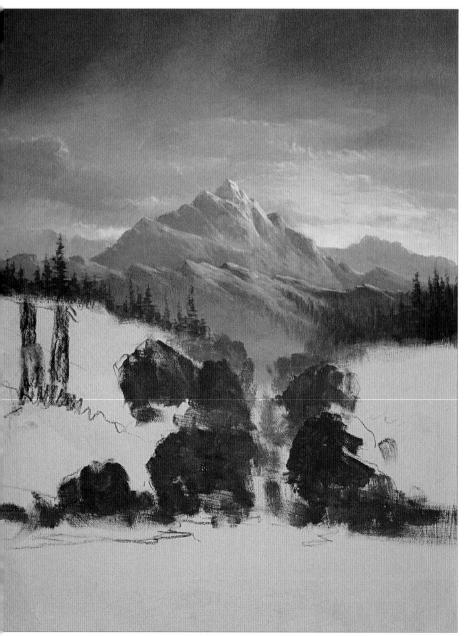

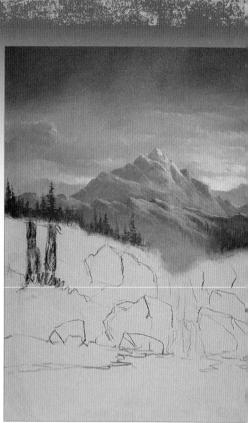

ID Underpaint Rock Formations This is always a fun step. Instead of creating a specific color mixture, you will mottle several colors on the canvas to underpaint the rock formations. With a no. 4 or no. 6 bristle, and using most of the darker values (Ultramarine Blue, Burnt Sienna, Dioxazine Purple, Burnt Umber, etc.), begin mottling these colors in the areas where the rocks go.

As you're mottling, add touches of white to the rocks to create three values. These values will be used as follows: The back rocks will be the lightest value; the middle rocks will be the medium value; and the foreground rocks will be the darkest value.

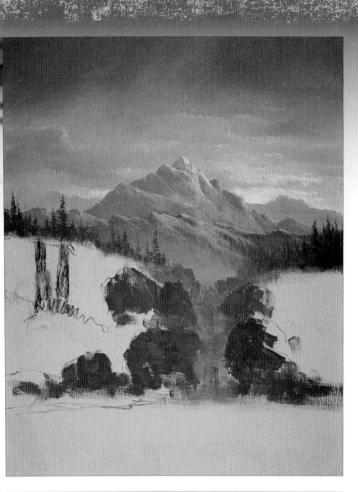

/ Underpaint Waterfall

Mix white + a touch of Ultramarine Blue + a touch of Dioxazine Purple. This particular color should be a little darker and a bit more on the purple side than the mist you painted in step 8. Use a no. 4 or no. 6 bristle to underpaint the water. Cover the canvas very well, as well as the edges of all the rocks.

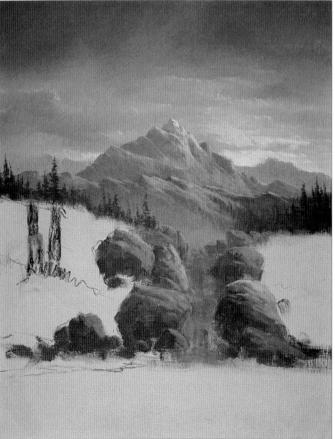

Highlight Rock Formation

Mix white + a touch of Cadmium Orange + a little bit of Ultramarine Blue. Remember, blue is the complement to orange, so we use it here to gray the orange. Make the mixture very creamy and load a small amount on a no. 4 bristle. Keep in mind the light source is from the back-right side, so when you highlight, highlight the top-right side of each of the rocks. You can increase the brightness of this highlight later, so be careful not to overhighlight. Be sure your rocks have very good shapes, each unique from the others. **13 Highlight Waterfall** First, create a mixture of white + a touch of Cadmium Orange to create a tint. This should still appear white, so if your mixture has too much orange, make sure the white is dominant in the mixture. Make the tint very creamy and then load a small amount on the very tip or chisel edge of a no. 4 bristle. Then, holding your brush horizontal to the canvas and pointed straight at it, start at the top of the waterfall and pull downward with a very light, dry-brush stroke. Use this process lightly all the way down as you do each section of the waterfall.

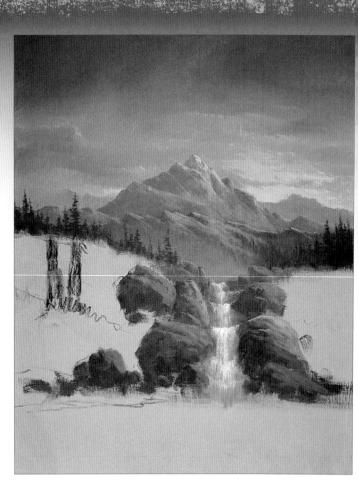

/ Inderpaint Meadow

Starting at the base of the meadow, use a no. 10 bristle and mottle on Hooker's Green with touches of Burnt Sienna and Dioxazine Purple. Apply the paint fairly thickly. As you go upward toward the top of the meadow, begin adding touches of Thalo Yellow-Green, Cadmium Yellow Light and Cadmium Orange.

While everything is still wet, take your brush and, beginning at the top of the meadow, push the grass upward, working your way down to the darker areas. This will create a grasslike texture. The paint needs to be applied fairly thickly in order for this technique to work properly.

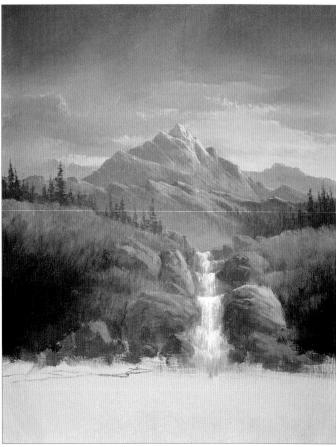

CUnderpaint Water

1 O Mix one part Ultramarine Blue + one-fourth part Hooker's Green + about one-eighth part Dioxazine Purple. Load a no. 6 bristle fairly heavily. Starting at the bottom of the canvas, begin applying this color using short, choppy, horizontal strokes. As you move up toward the waterfall, begin adding touches of white to create various value changes until you have achieved approximately three value changes from light to dark. However, notice that the area along the shoreline is darker.

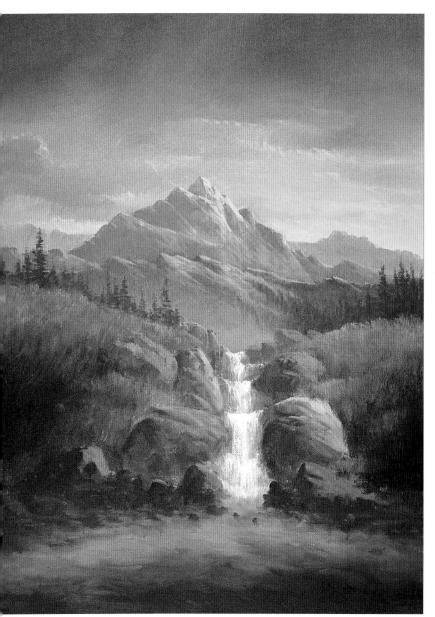

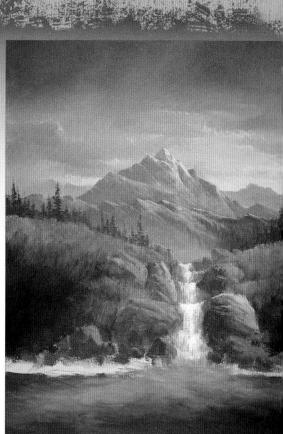

JG Underpaint Water's Edge Mottle some dark colors as you did when underpainting the rocks in the waterfall. With a no. 4 or no. 6 bristle, take Burnt Sienna + touches of Ultramarine Blue and Dioxazine Purple. Scumble these colors along the shoreline and up toward the grass. You may want to add touches of white to create some miscellaneous value changes. This area will eventually become rocks, so it's OK if you leave a lot of brushstrokes and even more texture.

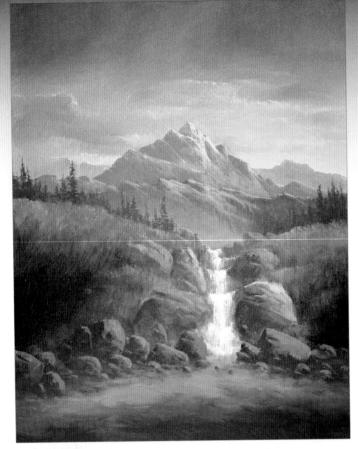

7 Highlight Water's Edge

Use the original rock highlighting mixture of white + a touch of Cadmium Orange and a little Ultramarine Blue, which will gray the color so it will be a little softer. Load a small amount on a no. 4 bristle; you can also use your no. 4 flat sable. Begin highlighting the smaller rocks and pebbles along the shoreline. Once again, be careful not to overhighlight. We will apply the final highlights later.

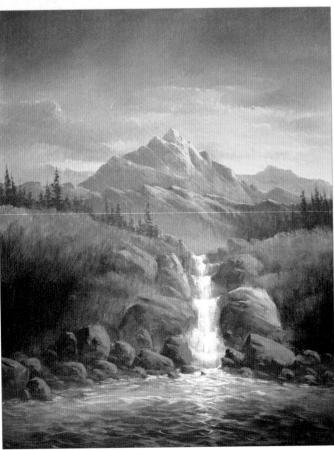

📿 Ripple and Highlight Water

Create a water highlight color of white + a slight touch of Ultramarine Blue + a slight touch of Hooker's Green. This is only a tint, so don't add too much color. Make the mixture nice and creamy and load it fairly heavily on a no. 4 round sable. Starting at the base of the waterfall, begin highlighting the water by using short, choppy, horizontal strokes, creating numerous, interesting pockets of negative space. It's important to reload your brush very often to make sure the highlight color stays nice and bright.

20 Underpaint Dead Pine Trees

Mix one part Burnt Sienna + onefourth part Ultramarine Blue + just a slight touch of white to create a nice medium-to-dark brownish gray. Use a no. 4 flat sable to paint in the large dead tree on the right side. Then paint in the closest fallen log.

When you finish these two items, change the value of the dead-tree mixture by about two or three shades and add the background fallen logs.

角 Underpaint Large Pine Tree

Mix one part Hooker's Green + one-fourth part Dioxazine Purple + one-fourth part Burnt Sienna. This should be a very dark, deep forest-green color. Before you start painting, you may want to take your soft vine charcoal or your white Conté pencil and draw a rough sketch of the basic shape. Then heavily load a no. 4 or no. 6 bristle with the tree mix. Turn the brush horizontally to the canvas, and, beginning at the center of the tree, start dabbing on this color, working your way outward and upward. This will gradually create the shape of the tree. It's important that you put the paint on fairly thickly so the tree has a little texture.

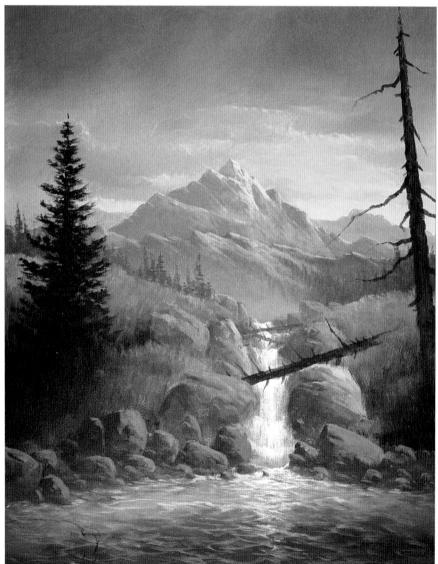

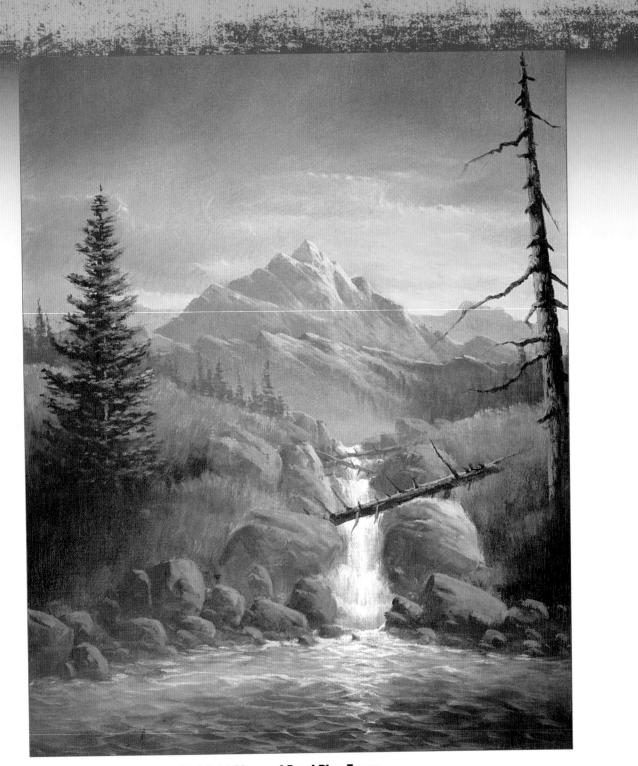

🄿 👖 Highlight Live and Dead Pine Trees

To highlight the large live tree, mix Thalo Yellow-Green + a touch of Cadmium Orange + a touch of Hooker's Green. You can adjust this color to fit your own taste by adding more or less of any of the lighter colors. If you want more of a greenish highlight, add more green, a touch more yellow or even orange. Load the very tip of your no. 4 bristle and dab this color on the right side of the pine tree.

Mix the highlight color for the dead pine trees—white with a slight touch of Cadmium Orange and Burnt Sienna. Using short, choppy, vertical strokes with a no. 4 round sable, highlight the left sides of the dead trees. Then highlight the topsides of the fallen logs.

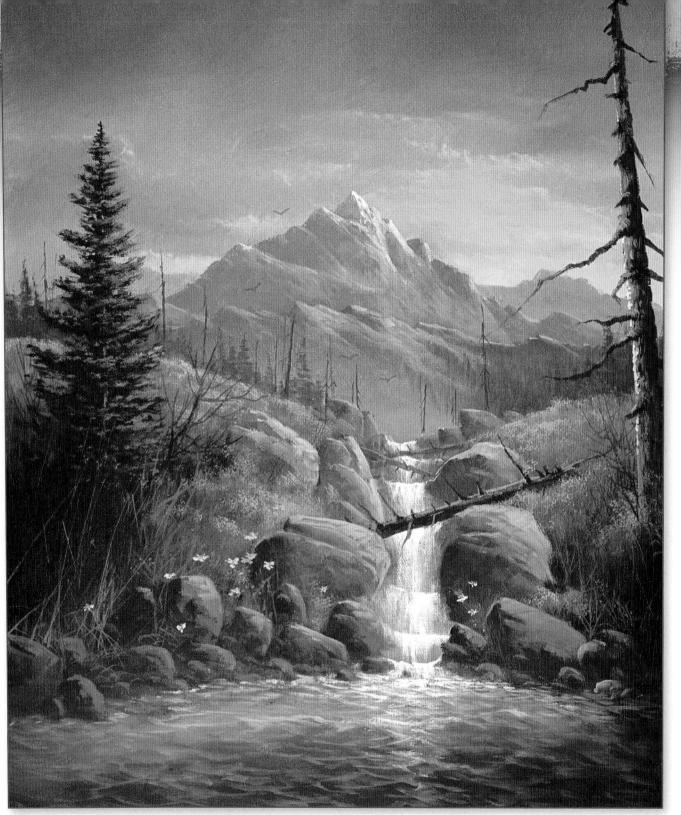

γ γ Add Final Details and Highlights

With the exception of adding a few flowers, this step is mostly about using your artistic license to highlight and add a few details such as tall weeds, tree limbs, etc.

Create a couple very light-colored inky mixtures. Then take your no. 4 script liner and paint in some tall weeds.

Make a dark, inky mixture of one part Burnt Sienna + one-fourth part Ultramarine Blue. Use this mixture to paint

in the tree limbs and any dead bushes you like. Then, with a little pure color (Cadmium Red Light, Cadmium Orange, Cadmium Yellow Light), take your no. 6 bristle and dab on a few miscellaneous wildflowers.

After you're satisfied with all the details you wanted to add, rehighlight any areas you feel need to be brighter.

Once again, as I always say, don't piddle, play or putter.

FULL PAINTING DEMONSTRATION

Stormy Skies

For many artists, one of the most inspiring things to paint is a dramatic sky formation. They are beautiful and inspiring to look at, and they also create a host of artistic challenges. The fact is that a dramatic sky (such as the one you will create in this study) will challenge even the most advanced artists. There's a large variety of color changes, value changes and compositional arrangements of negative space to create good eye flow, and, of course, there is the ever-daunting task of being able to blend everything to create softly rounded edges and subtle value changes.

As you begin the blending process for the basic cloud formations, watch for unique, interesting shapes that accidentally appear from time to time as you paint. Though you may be trying to copy my cloud formations as a guide, it's impossible to create the exact arrangement. Use your artistic license and just let the clouds appear. When you see a formation you like, leave it alone.

> /stormy/skies 20" × 16" (51cm × 41cm)

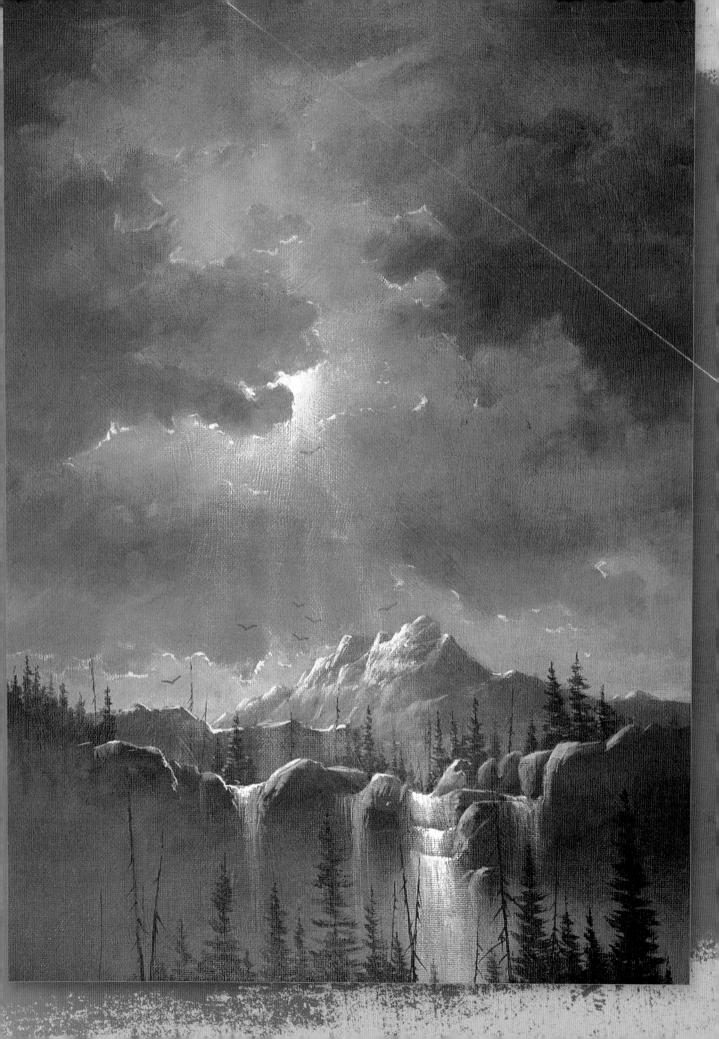

Underpaint Mottled Background

It's important to completely cover the canvas with a grayish, mottled color. This background color will show through in some of the less blended areas of clouds, and it helps your eyes adjust to the blending process more efficiently.

Begin applying gesso with large "X" strokes of a hake brush. As you go, begin adding Ultramarine Blue, Burnt Sienna and maybe a few touches of Dioxazine Purple. The trick is to mottle them until you have a nice, grayish background.

Note: Do not overblend. It's OK to see brushstrokes.

Create Basic Sketch

Use your soft vine charcoal to draw a simple sketch of the basic mountain layout and basic location of the waterfall and rock formations. It's not necessary to sketch in all of the cloud formations, because they will change their shape as you blend them.

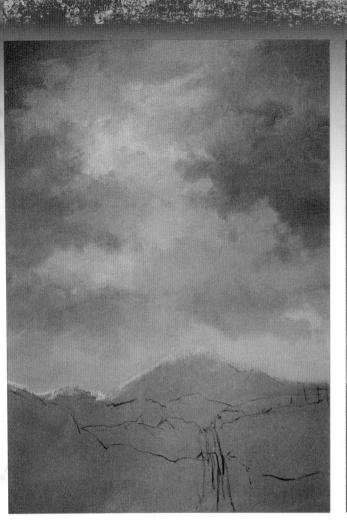

🔉 Underpaint Clouds

This is a fairly difficult step to explain without actually showing you in person, but I will do my very best. First, take your no. 10 bristle and load it with a small amount of gesso; then begin scrubbing the gesso on the canvas using the side of the brush.

While the gesso is still wet, begin adding touches of Ultramarine Blue and Burnt Sienna, plus a little Dioxazine Purple. Scrub these colors together, creating various values and hues. The most important thing is to create very unique, interesting pockets of negative space.

Rinse your brush and reload it with white and touches of Cadmium Red Light and Cadmium Orange. Scrub softly around your sketch (no need to be exact) to create a sunset effect. Scrub the same mixture in soft, warm highlight areas around the darker cloud formations. Be sure the mixture you are working with is creamy and all the cloud edges are soft. You will have to experiment with different brush pressures and the wetness or dryness of your mixture to achieve proper blending.

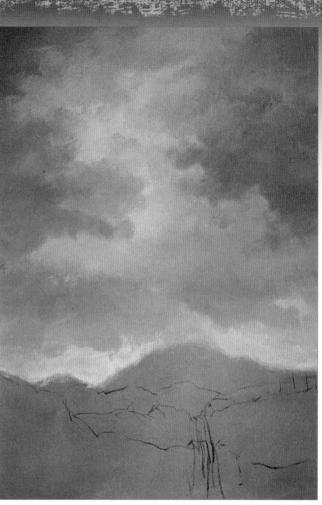

👔 Highlight Sky

Switch to your no. 6 or no. 4 bristle. Use your palette knife to mix white + touches of Cadmium Yellow Light and Cadmium Orange. This should be a soft, medium gold tone on the orange side. Load a small amount on the brush and begin scrubbing in the brighter color, creating a nice, warm contrast against the darker gray clouds. Because acrylics dry a bit darker, you may want to repeat this process until you're happy with the degree of brightness. You may need to go over the area two or three times to achieve your desired look.

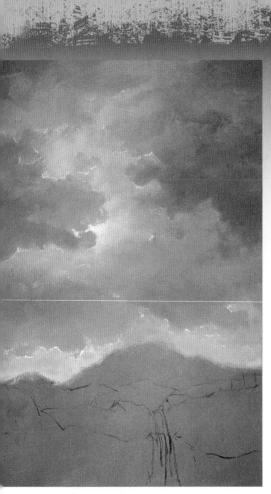

5 Add Silver Linings and Sun Glow The sky really starts coming alive in this step. Mix a small amount of highlight color (white + equal parts Cadmium Yellow Light and Cadmium Orange). Load a no. 4 flat sable and paint in the sunglow around the back edge of one of the cloud formations make sure this is not too high in the sky. Gradually fade the glow out from the main source so there is no hard edge.

Take a small amount of this color and add equal amounts of white to lighten it. Load the very tip of a no. 4 round sable. Paint the silver linings on the edges of the clouds as seen in this photo.

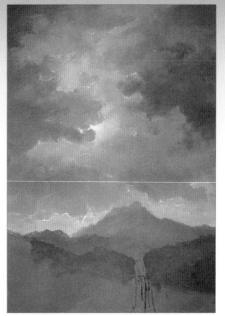

G Underpaint Mountains Mix a very light, soft, grayish purple from white + a touch of Ultramarine Blue + a touch of Burnt Sienna + a touch of Dioxazine Purple. Use a no. 4 flat bristle to block in the very background mountains.

After you have done that, slightly darken the mixture you just made with a little more Ultramarine Blue and Burnt Sienna. Paint in the middle group of mountains.

Darken the mixture with a bit more Ultramarine Blue, Burnt Sienna and Dioxazine Purple. Block in the rock area above and around the waterfalls. You should have three value changes.

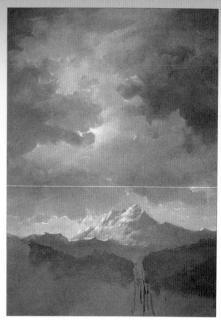

7 Highlight Background Mountains

The highlight color for this step is white + a touch of Cadmium Yellow Light + a touch of Cadmium Orange. Thin the mixture to a very thin, creamy consistency. Load a small amount on a no. 4 flat sable. Use very light, choppy strokes to paint the highlights; leave very interesting pockets of negative space to create the suggestions of cracks, crevices and ridges.

Repeat this step as often as necessary until you're happy with the brightness of the highlights. Be very careful not to create the same repetitive shapes over and over. You want your mountains to have irregular pockets of negative space.

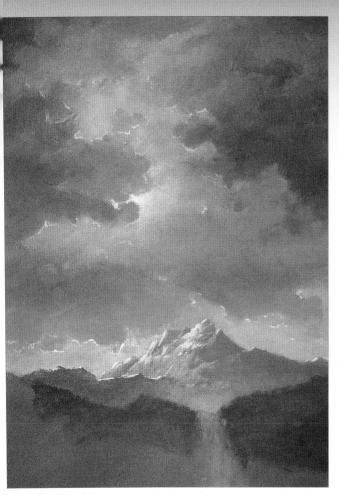

8 Underpaint Mist and Waterfall Create a very soft, clean, bluish color by mixing two parts white + one part Ultramarine Blue. Add a slight touch of Dioxazine Purple; be sure not to get this mixture too purple. Load a very small amount on the end of a no. 4 flat bristle. Beginning at the base of the mountain and the top of waterfall, use small, tight, circular motions and gradually scrub in the mist, feathering upward.

Reload the brush and underpaint the area where the waterfall is going to be. Be sure the canvas is well covered and the edges are blended out very softly.

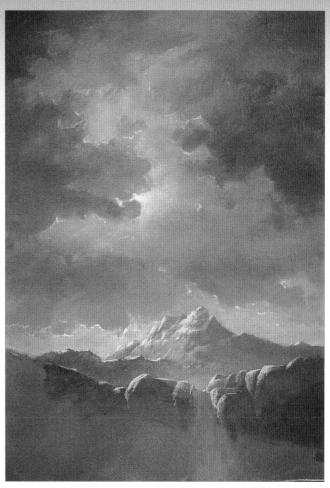

Highlight Rock Formations

This is where the challenge begins: Creating the rocks is a difficult process for most artists. Take the highlight mixture from step 7 and add a bit more Cadmium Orange to make it richer.

Load a very small amount on the tip of a no. 4 flat bristle and carefully paint the highlight that forms the shape of the rocks. (You may have to add a little more water to thin the mixture to help apply the highlight easier.) Keep in mind that the sun is above and slightly to the left of your rock formations. Make sure every rock has its own individual shape and they overlap each other in an irregular fashion. Repeat this process to brighten the rocks and to possibly change the configuration of the rock formations. Don't be afraid to paint out an area and start it over, if necessary.

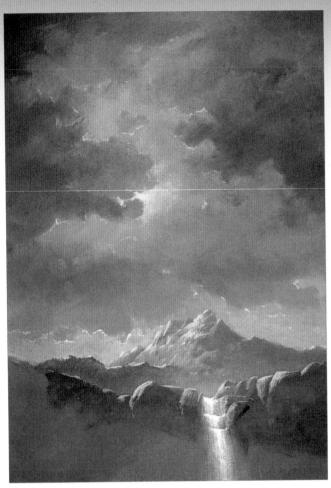

Highlight Waterfall Load the very tip of a no. 4 bristle with a very small amount of creamy white. With a light touch, start at the top of the waterfall and very carefully drag downward about 2 inches (5cm) to form the waterfall's first drop.

At the bottom of this section, repeat the same stroke to form the second drop. The last drop goes all the way off the canvas. Use a very light, soft touch.

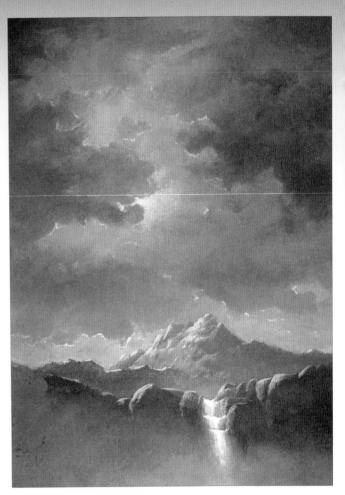

/ Paint Foreground Mist

Load a small amount of the bluish mist color from step 8 on the end of a no. 6 bristle. Start at the bottom of the painting and use tight, circular motions to create mist. Begin blending upward all across the bottom of the painting and up to the base of the rock formations and across the waterfall. Be sure this is a very gradual fade as you go up toward the rock formations. It's critical that you don't leave any hard edges as you blend up into the rock formations. It's also important that you don't overblend in an area, or you will rub a hole in the mist. Be careful.

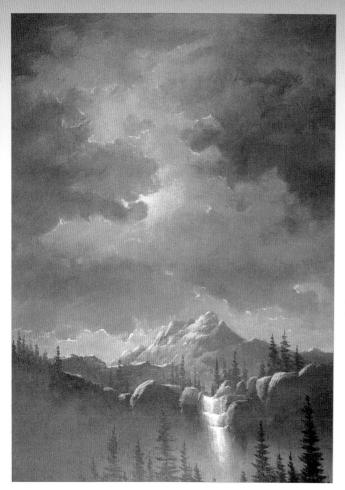

1 🥥 Paint Pine Trees

Green + one-fourth Dioxazine Purple + one-fourth Burnt Sienna + enough white to create the proper value for your painting. Load a no. 4 flat sable and begin painting the trees along the top of the ridge of rock formations.

Slightly darken the mixture by adding a touch more Hooker's Green and Dioxazine Purple. Switch to a no. 4 bristle and paint the foreground trees. Remember to create a wide variety of shapes, sizes and interesting pockets of negative space around the trees.

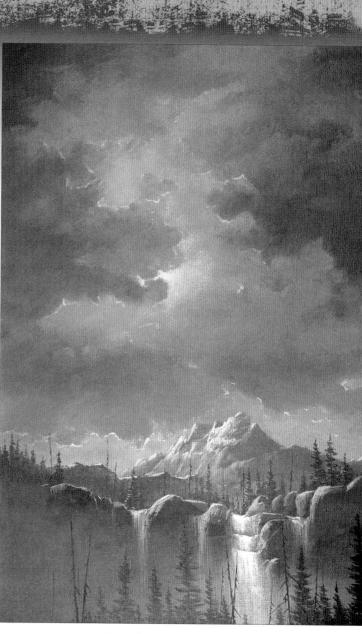

Add Details and Highlights

In this step, let your artistic license be your best friend and have fun applying various details that fit your own way of thinking and that would most effectively fit your composition, color scheme and value system.

I added a couple small waterfalls to the left of the main waterfall. You may need to add only one, or none depending on the arrangement of your rock formations. It's probably a good idea to add a few dead pine trees or maybe even a fallen log across the waterfall using your no. 4 script liner. Be careful not to make it too busy.

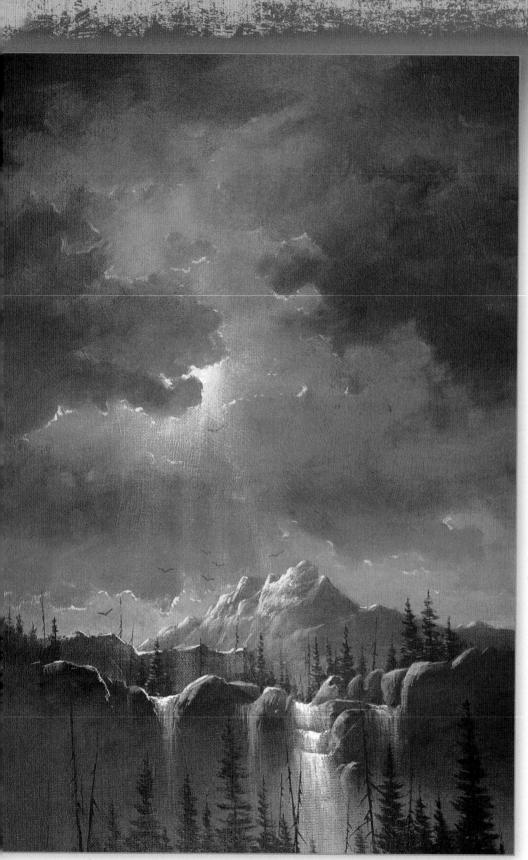

14 Add Sun Rays and Silver Linings

This is the final step, but believe it or not, it can make or break your painting, so follow these instructions carefully.

First, create a small amount of tinted white (white + a very slight touch of Cadmium Yellow Light). Load a very small amount on the tip of a no. 6 bristle and then wipe most of it off with a paper towel or rag. Starting at the sunglow, using very light pressure, skim the brush along the surface of the canvas with quick, straight strokes; work your way around the sun like spokes on a wagon wheel. You can go over these rays as many times as you wish until you get them as bright as you want, but keep them very soft. You can also brighten the silver lining on the clouds and edges of the mountains.

Apply the Lesson

This example of cloud formations was taken from one of my paintings, entitled Desert Dreams. I thought this would be a perfect example of how you can use the technique for creating stormy skies. With many different varieties of values and tonal changes, this painting is uniquely interesting. In addition, the original artwork is a fairly large and narrow vertical painting, which is one of the more challenging shapes for creating a good composition. However, when using the scumbling technique to create the irregular shapes of the clouds, it's much easier to make adjustments in the shapes and forms of each cloud formation.

The important thing to remember is if you're going to do a vertical painting of clouds, it's much easier to start at the bottom of the sky or at the horizon area. Then you can work your way upward. Notice that in this particular painting, your eye flows gracefully up the center of the sky, weaving its way in and out of the unique pockets of negative space. I want to remind you that you don't want to have any areas of eye flow that lead your eye off the canvas without an easy way back in. I hope you enjoyed and learned a lot from this study—especially how to make your work unique!

Desert Dream 15" × 30" (38cm × 76cm)

Closing Statement

I hope you enjoyed this study of a beautiful sunset, stormy sky and waterfall. There were many things to learn here. The most important thing to remember is not to overblend, overhighlight, or add too much detail. You don't want any objects to compete with the main focal area, which is the sunburst and rays shining on the mountain and waterfall. Also, I might mention that if you are struggling with any of these steps, don't frustrate yourself by using them on your finished painting. It's best to get a scrap canvas and practice whatever it is you're struggling with until you're comfortable with the technique and process involved. So have fun, and don't piddle, play or putter! Acrylic paint, 13 Alcohol, denatured, 15 Arches, creating, 78–83 *Autumn Wonders*, 2-3, 88–89

Banks, eroded, 50–52 Bark, tree, 90–91 Basic color list, 13 Bleach, chlorine, 15 Blending, 10 Blocking in, 12 Boards, canvas, 18 Bristle brush, 14 Brush cleaning tips, 15 Brush, parts of, 15 Brushes, 13–14 Bushes, 93, 114–116

Canvas, 18 Charcoal, 19 Cleaning of brushes, 15 Cliffs, 50-52 Clouds, 135. See also sky Color complements, 10 Color list, 13 Color value, changing, 12 Color wheel, 10, 12, 13, 21 Colors, mixing of, 13, 94–97 Complementary colors, 10, 13 Complements, understanding, 21 Conté pencil, 19 Cracks in wood, 27 Creamy paint consistency, 10 Creek Runs Through It, A, 53

Dabbing, 10 Daisies, 52 Dead trees, 90–93 Denatured alcohol, 15 *Desert Dreams*, 141 Dimension, adding to stones, 44 Dirt, 22, 30–33, 70 Dirt road, 34–37 Double loading, 10 Dowel rods, 20 Dried paint, softening of, 15 Drybrushing, 10 Drying of brushes, 15

Easel, 18 Economy grades paints, 13 Edges, softening of, 10 Ellipses, 39 *End Of The Rainbow*, 5-6, 82–83 Eroded banks, 50–52 Eye flow, 10

Falling snow, 102–103 Feathering, 10 Fence posts, 26–27, 71–72 Flowers, 25. *See also* wildflowers Foliage. *See* leaves

Gesso, 11 Glaze, 11, 68 Grades of paint, 13 Grass at base of rocks, 48 clumps, 22, 66, 71–72 highlighting, 24, 36, 40, 52, 61 under tree, 87 underpainting, 22, 35, 40, 51, 59 Grayed complements, 21

Hake brush, 14 Heaven's Warning, 76–77 High-Country Waterfall, 118–119 Highlighting dirt, 30, 70 fence, 27 grass, 24, 36, 61 leaves, 85–86 pebbles, 32–33 rainbow, 81 road, 35 shoreline, 66 snow, 92–93, 100, 111–114 stones, 40, 43 trees, 66, 91, 98–99 waterfall, 126 Horizon line, 64

Indian Pony, 29 Inky paint consistency, 10 Intermediate colors, 20

Just Chillin', 45

Knife, palette, 19 Knotholes, 27

Leafy trees, 84–89 Leaves, 84–89 Lighting, 18 Lightning, 74–77 Limbs, tree, 86 Liner brush, 14 Loading brush, 10 Logs, fallen, 129–130

Mahlsticks, 20 Materials, 13 Meadow, 126 Mildew prevention, 15 Mist, 123, 137, 139 Mottling, 11, 134 Mountains, 79–82, 107–109, 121–123, 136–137 Mud puddles, 70–73

Natural light, simulation of, 18 Negative space, 11

Ocean waves, 54-57

Paint, acrylic, 13

Paint, consistency of creamy, 10 inky, 11 Paints, placement on palette, 17 Palette glass, 15, 17 limited, 13 setting up, 16-17 Sta-Wet palette, 15–16 wet, 15–17 Palette knife, 19 Pastel pencil, 18 Pathway, stone, 38-41 Peace Be Still, 7-8, 69 Peaceful Waters, 62-63 Pebbles, 23, 30-33, 71 Pine trees, 90-93, 94-101, 110-115, 124, 128-130 Prestretched canvas, 18 Primary colors, 20 Professional-grade paints, 13 Puddles, 70-73

Rainbows, 78–83 Reflected highlights, 48, 91 Reflections in water, 64–67 Ripples (in water), 68, 128 Road, dirt, 34–37 Rocks, 23, 46–49, 55–56, 59–60, 124 Running water, 58–63 Ruts (in road), 36

Sable brush, 14 Script liner brush, 14 Scrubbing, 12 Scumbling, 12 Seascape, 54–57 Secondary colors, 20 Shadows, 23, 31, 41, 47, 96–97, 110 Shoreline, 65–66 Silver linings, 136, 141 Sky, 54, 64, 74–77, 78–83, 106, 120–121 *See also* clouds

Snow

at base of tree, 92–93 and blue shadows, 110 falling, 102-103 true coloring of, 104 Snow Country, 104-105 Snow-covered pine trees, 94-101 Snowflakes, spatter technique, 102-103 Soft vine charcoal, 19 Spattering dirt, 31-32 pebbles, 71, 110 snow, 102-103 Spot highlighting, 93 Spray bottle, 19 Stedi-Rest, 20 Stone pathway, 38-41 Stone wall, 42-44 Stormy Skies, 132–133 Stormy sky, 74–77 Stream bed, 58 Stretched canvas, 18 Student-grade paints, 13 Stump, dead, 67 Sun glow, 136 Sun rays, 141

Tertiary colors, 21 Toothbrush, 23, 102–103 Transparent colors, 78–83 Trees background, 95 bark, 90–91, 115 dead, 90–93 distant, 65–66, 110, 124 foreground, 96 leafy, 84–89 limbs, 86, 91 pine, 90–93, 94–101, 110–115, 124, 128–130 trunks, 87 Underpainting clouds, 135 defined, 12 dirt, 22, 30, 70 fence, 26 leaves, 85 puddles, 71 rainbow, 80 road, 34 snow, 92, 99, 111–112 stones, 39, 43 trees, 90, 129–130 water, 55, 64, 127

Value, 12 Viewing distance, 12

Wall, stone, 42-44 Wash, 11 Water calm, 64–67 highlighting, 55, 60-61 puddles, 70-73 reflections in, 64-67 ripples, 68, 128 running, 58-63 splashes of, 56 underpainting, 55 Waterfall, 125-126, 137-138 Water's edge, 127-128 Waves, 54-57 Waterfall, 125-126, 137-138 Waves, ocean, 54-57 Weeds, 24, 27, 93, 116 Wildflowers, 26-28. See also flowers Wood grain, 27 Wood, weathered, 26–27

The best in painting instruction and inspiration is from North Light Books!

Achieving Depth and Distance

Achieving Depth and Distance helps you paint realistic landscapes by showing you the right colors, values and textures to express near, middle and great distance. Ten stepby-step demonstrations on canvas teach you how to paint a wide variety of subjects, scenery and seasons with a convincing depth of field. Colorful diagrams, reference photos, and eye-catching side-by-side comparisons make it easy and fun to learn these important techniques.

ISBN-13: 978-1-60061-024-0, ISBN-10: 1-60061-024-2, paperback, 144 pages, #Z1308

The Complete Guide to Painting Water

Water is a fascinating yet challenging subject to paint. It changes forms, moods, shape and color as the surrounding influences are altered. Now you can learn how to paint water in all its forms and learn to incorporate that water into your landscape or still life painting. You'll also learn how to carefully observe water to capture its action and reactions—how it reflects and refracts light, how it moves and much more—in order to master this ever changing subject.

ISBN-13: 978-1-58180-968-8, ISBN-10: 1-58180-968-9, hardcover, 144 pages, #Z0711

Creating Textured Landscapes with Pen, Ink and Watercolor

Bring your watercolor landscapes to life with the rich texture of pen and ink. With the help of reference photos and field sketches, bestselling author Claudia Nice teaches you how to create realistic and colorful landscapes ranging from expansive mountain vistas to more intimate vignettes such as tree-shaded streams. Each chapter explores a different component of landscape painting: skies and clouds, hills and mountains, trees and foliage, rivers, lakes and waterfalls, rocks, flowers and more.

ISBN-13: 978-1-58180-927-5, ISBN-10: 1-58180-927-1, hardcover, 144 pages, #Z0568

Painting With Brenda Harris Volume 3: Lovely Landscapes

Beloved TV painter Brenda Harris brings all the charm and approachability of her PBS show directly to you with this instructional guide. In this third installment of her series, Harris provides you with: ten easy-to-follow step-by-step demonstrations that result in beautiful acrylic paintings; instruction that requires no prior knowledge of art; and project patterns that reduce the fear of making mistakes.

ISBN-13: 978-1-58180-739-2, ISBN-10: 1-58180-739-4, paperback, 112 pages, #33416

These books and other fine North Light books are available at your local arts and crafts retailer, bookstore or from online suppliers, or visit our Web site at www.mycraftivity.com.